D1099934

STROUD COLLEGE LIBRARY

TWO WEEK LOANS
This book **MUST** be returned
LIBI

Stroud College of Further Education

T19952

5.98

FLORAL
NEEDLEPOINT

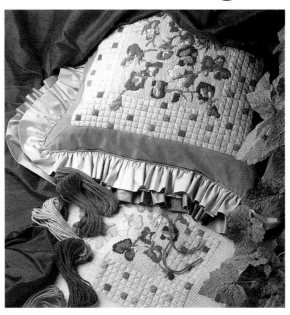

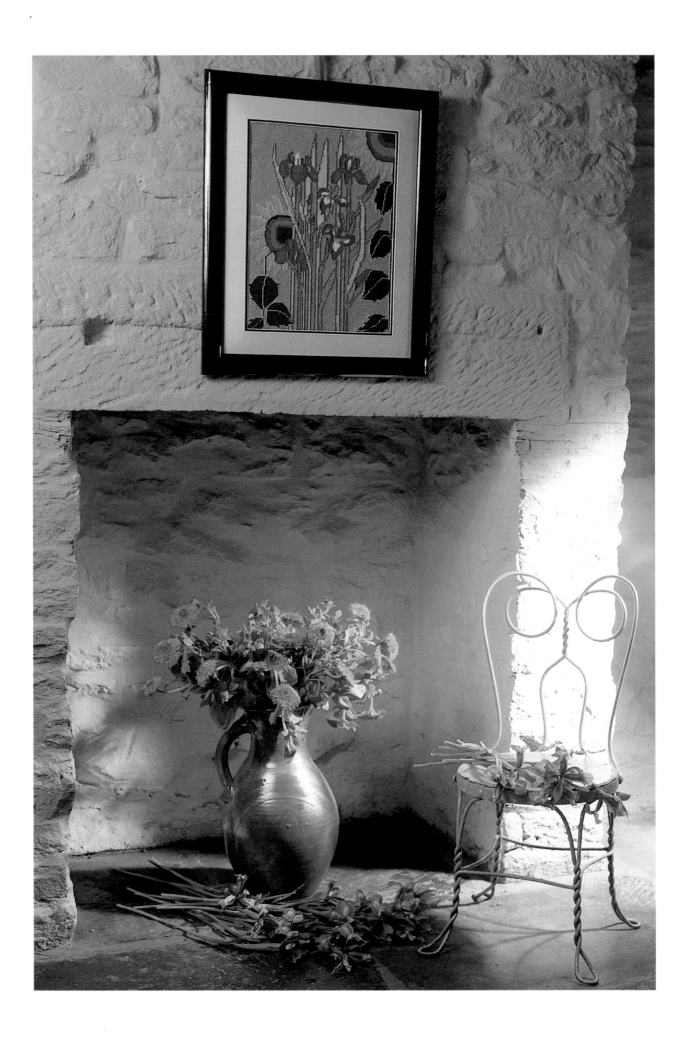

F L O R A L
NEEDLEPOINT

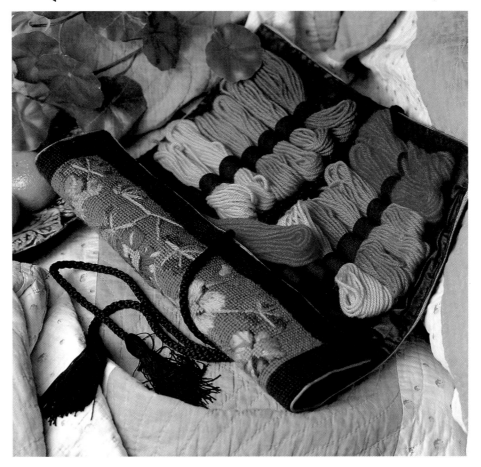

MELINDA COSS

Sterling Publishing Co., Inc. New York

746.44

STROUD COLLEGE
LIBRARY

T19952

*For Railea, who loved
pretty things*

Designed by Michael Atcherley
Photography by Di Lewis
Coordination and styling by Di Lewis
Charts drawn by John Hutchinson
Plant illustrations by Rosanne Sanders
Technique illustrations by Mike King

Library of Congress Cataloging-in-Publication Data Available

2 4 6 8 10 9 7 5 3 1

Published 1992 by Sterling Publishing Company, Inc.
387 Park Avenue South, New York, N.Y. 10016
Originally published in Great Britain in 1991 by
Anaya Publishers Limited, Strode House
44–50 Osnaburgh Street, London NW1 3ND
Text © 1991 by Melinda Coss
Charts and Illustrations © 1991 by Anaya Publishers Ltd
Distributed in Canada by Sterling Publishing
c/o Canadian Manda Group, P.O. Box 920, Station U
Toronto, Ontario, Canada M8Z 5P9

Printed and Bound in Hong Kong

All rights reserved

Sterling ISBN 0–8069–8792–8

CONTENTS

INTRODUCTION

There is a mystique surrounding the skill of needlepoint that I hope this book will positively lay to rest. Despite the glorious pattern and colour combinations and the fine details and shadings that can be achieved, the basis of needlepoint is one simple stitch that can be learned in a minute. For the knitters among us, needlepoint is a pleasant relief from the complications of achieving correct tensions, casting on and casting off, and sitting with yarn and needles crossed and twisted as we aim for some form of textural supremacy. When it comes to needlepoint we have, for our tools, a range of canvases, which can be selected according to the length of time we are prepared to invest in the work, sewing needles, with blunt ends that eliminate pricks and scratches, and thread . . . yards of wonderfully coloured yarns, which can be mixed together to create totally individual effects.

This book is also intended to show the many possible uses for the finished work. You can produce an almost endless array of cushions, upholstery and pictures or, by folding your work in different ways, you can turn a square into a handbag and scraps of canvas into greetings cards or bookmarks, producing gifts that cost little more to make than time and a good wish.

An additional aim of this book is to take you on a journey to the hidden world of flowers. While researching into the flowers that form the basis of the designs in this book, I discovered countless stories, traditions and healing remedies that our gardens have to offer. We take so much for granted nowadays that it is hard to imagine the historical events, myths and folklore that surround the wild flowers and pots of herbs that are so much part of our everyday life.

As a child, born in a capital city, I was privileged enough to enjoy the benefits of a large garden. One of my earliest recollections is of walking hand in hand with my father around the flower beds and learning from him the magical names of snapdragon, forget-me-not and foxglove and their Latin equivalents, which I endeavoured with great pride both to pronounce and spell. Then there was the story of the day my father won my mother's heart with a bunch of white lilac, and

there was the magnolia bush, which, to my child's eye, never seemed to grow simply because . . . I grew as it did. I'm sure all families have similar stories to tell, perhaps relating to a simple bunch of violets or a pressed buttercup, and can I be alone in experiencing a flood of nostalgia at the delicate perfume of wild honeysuckle or the sight of a wall clad with bunches of purple wisteria? Each flower brings back a special memory and an experience that will last a lifetime.

In our new 'green' society there is a revival in the belief in the value of the humblest of plants. This is evident in the growing interest in homeopathy and natural healing and even in aromatherapy, in which the subtle and pervasive qualities of floral scents are used to ease nerves and counter the stresses and strains of modern times. All these beliefs have historic precedents, and I hope you will find some of my discoveries in these areas both inspiring and interesting.

My approach to the projects in this book has been a totally free interpretation of flowers, which I have painted directly on to needlework canvas. Old seed packets, garden catalogues and, of course, the plants themselves have all proved wonderful sources of inspiration, and I hope that my ideas will, in turn, provide you with the impetus to produce your own designs. Simple designs can be accomplished with a set of five pots of acrylic fabric paints – red, blue, yellow, white and black. These paints are water-based and can be mixed on a palette (or in a saucer) to give an adequate range of colours and shadings. You can then add variations and detail by playing with different colours and combinations of yarns to achieve the final effect.

I am, first and foremost, a knitwear designer, and, in the same way that I taught myself to design knitwear, I have used what many needlework professionals would consider 'improper' methods and techniques to achieve my final results, both in the production of the needlepoints – Why can't I have knots at the back of my work? No one is going to see them. – and in the making-up process – Does the piping really have to fit in that seam and not the other one? My apologies to those among you with a better knowledge of the finer details, but I hope my finished projects will prove that you do not always have to take the orthodox route to achieve good results!

CLARY
SPECTACLE CASE

This neat spectacle case is worked entirely in tent stitch using six strands of Anchor stranded cotton, and it would make a lovely gift. You could line it with a quilted fabric to give the spectacles extra protection, or use the chart to make a greetings card (see page 26).

The botanical name of common clary is *Salvia sclarea*, and *sclarea* is believed to originate from the Latin word *salveo* meaning 'I heal'. The word clary itself derives from *clarus* (clear), and apothecaries used to make eye salves from the plant, which accounts for two of its popular names, clear eye and Christ's eye.

In the Middle Ages it was a common medical practice to place a whole clary seed under the eyelid and to leave it until it dropped out (the seed, not the eye), which was believed to 'take off the film which covereth the sight'. The plant's virtues were so widely appreciated that it was occasionally known as *Officianalis Christi* or *Oculus Christi*, which some writers considered blasphemous. Clary seeds, beaten to a powder and taken in wine, were also thought to be an aphrodisiac.

The essential oil of clary is sometimes used as a tonic to treat nerves and depression, and it is also said to help insomnia, asthma and dry skin. However, it should be noted that the oil can have an intoxicating effect, and it should not be administered to anyone about to drive a vehicle nor should it be taken during pregnancy.

In Germany, meadow clary is known as *Muskateller Salbei*, and it is used to convert wine into Muscatel. Before hops were introduced it was used in England to flavour ale.

COMMON NAMES – Christ's eye, clear eye, eyebright, orvale, see bright and toute-bonne.

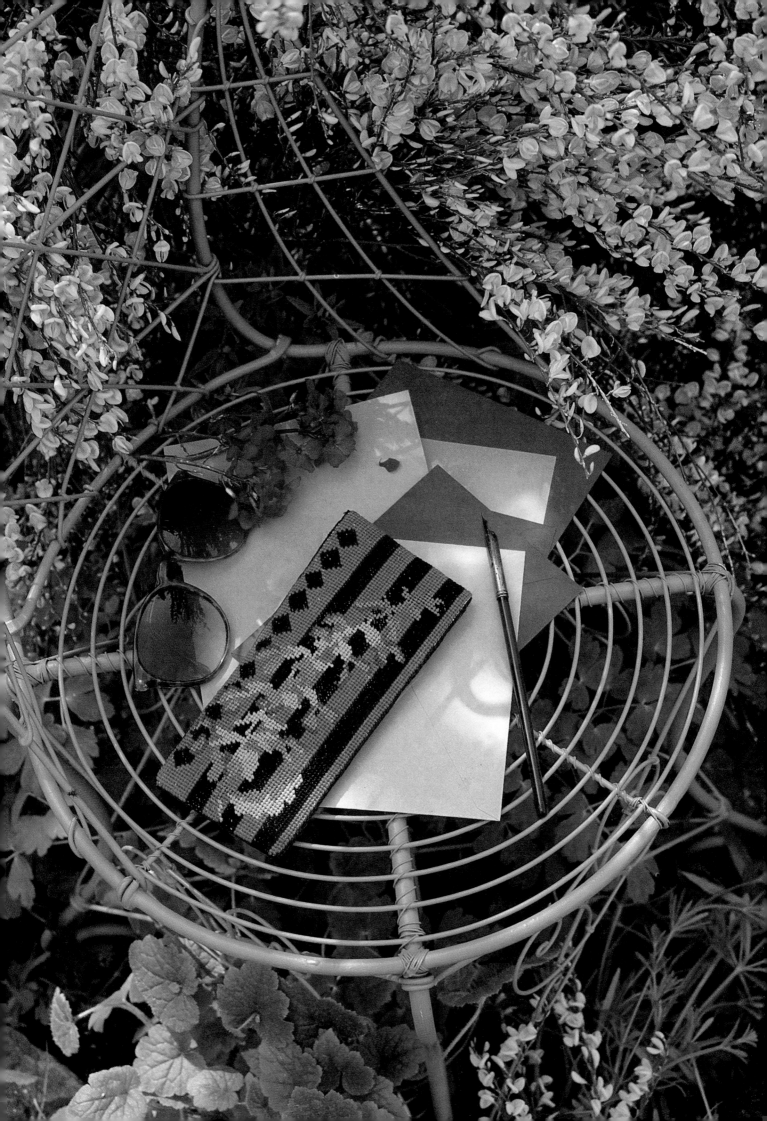

CLARY WINE

Take twelve pounds of Malage Raisins, after they have been pick'd small and chop'd, put them into a Vessel, and a quart of Water to each pound. Let them stand for ten or twelve days, being kept close cover'd all the while stirring them twice every Day: afterwards strain it off, and put it up in a Cask, adding a quarter of a Peck of the Tops of Clary, when it is in Blossom; then stop it up close for six Weeks, and afterwards you may bottle it off, and it will be fit to drink in two or three Months. It will have a great Settlement, therefore it should be tapp'd pretty high, or drawn off by Plugs.

CARTER'S HERBAL, 1736

CLARY

Some brewers of Ale and Beere doe put it into their drinke to make it more heady, fit to please drunkards, who thereby, according to their several dispositions, become either dead drunke, or foolish drunke, or madde drunke.

LOBEL

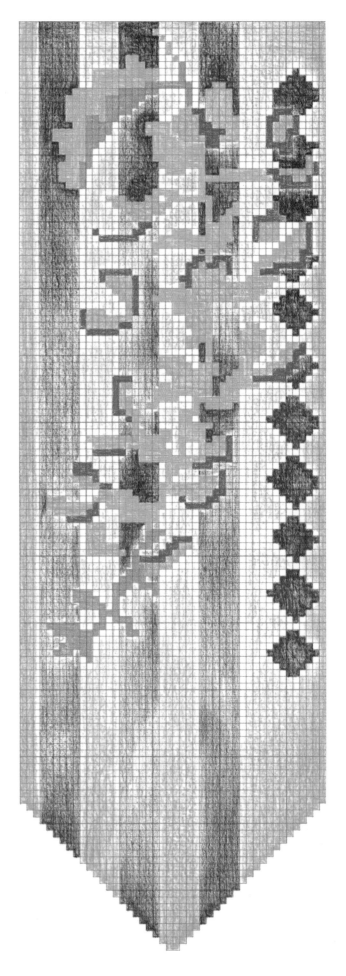

MATERIALS

1 piece of 11-mesh interlocked canvas,
 12 × 6in (30 × 15cm)
10in (25cm) thick or quilted lining
 fabric
Strong sewing cotton
Blunt- and sharp-ended needles
Waterproof pen
Press stud or small piece of Velcro
Anchor stranded cotton – use six
 strands throughout

3 skeins fuchsia (087)
1 skein mid-green (0205)
1 skein dark green (0230)
1 skein blue (0118)
1 skein dark blue (0119)
3 skeins black (0403)

METHOD

Mark the position of the chart on the canvas and work the design in tent stitch throughout. When complete, block the canvas (see Techniques, page 104) and fold back the waste edges, taking especial care at the point. Cut a piece of lining fabric to fit and sew it neatly to the back of your needlepoint. Cut a second piece of lining fabric 7 × 3in (17.5 × 7.5cm) plus a turn-in of ½in (1cm) and stitch it to the canvas over the first piece of lining, leaving the point area and 1¼in (3cm) at the top free for the turn over. Attach a press stud or piece of Velcro to the point.

SPECTACLE CASE · 11

CLOVER BOOKMARK

Bookmarks are excellent projects for using up scraps of canvas and yarn. With a little imagination, no end of shapes and designs can be produced, and the addition of unusual fringes and tassels makes them wonderful gifts. I have worked the background and leaves of the bookmark illustrated here in tent stitch and the flowers in overlapping straight stitches.

The deliciously fragrant wild clover, *Trifolium pratense*, grows abundantly in meadow land. Honey is produced from the flowers, which attract a large number of bumble bees.

In a small cemetery in New Orleans the clover leaves are reported to bear a red, heart-shaped spot called 'the mark of Jesus' blood', and the old people of the French quarter tell the story of a girl who died on the eve of her marriage and was buried there. Her distraught lover shot himself beside her tomb, and all the clover that grew there afterwards has the spot of red on its leaves.

Four-leaved clover is said to bring good luck, and the phrase 'in clover', which is used to describe good fortune and plenty, is derived from the contentment of cattle which have been put to graze in pastures that are rich with clover. It is said that if you dream of clover good luck is on the way.

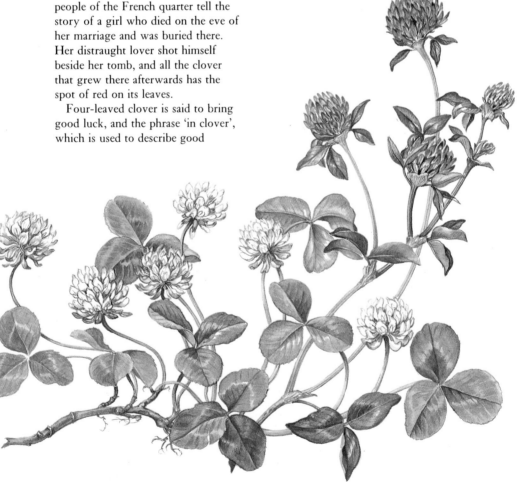

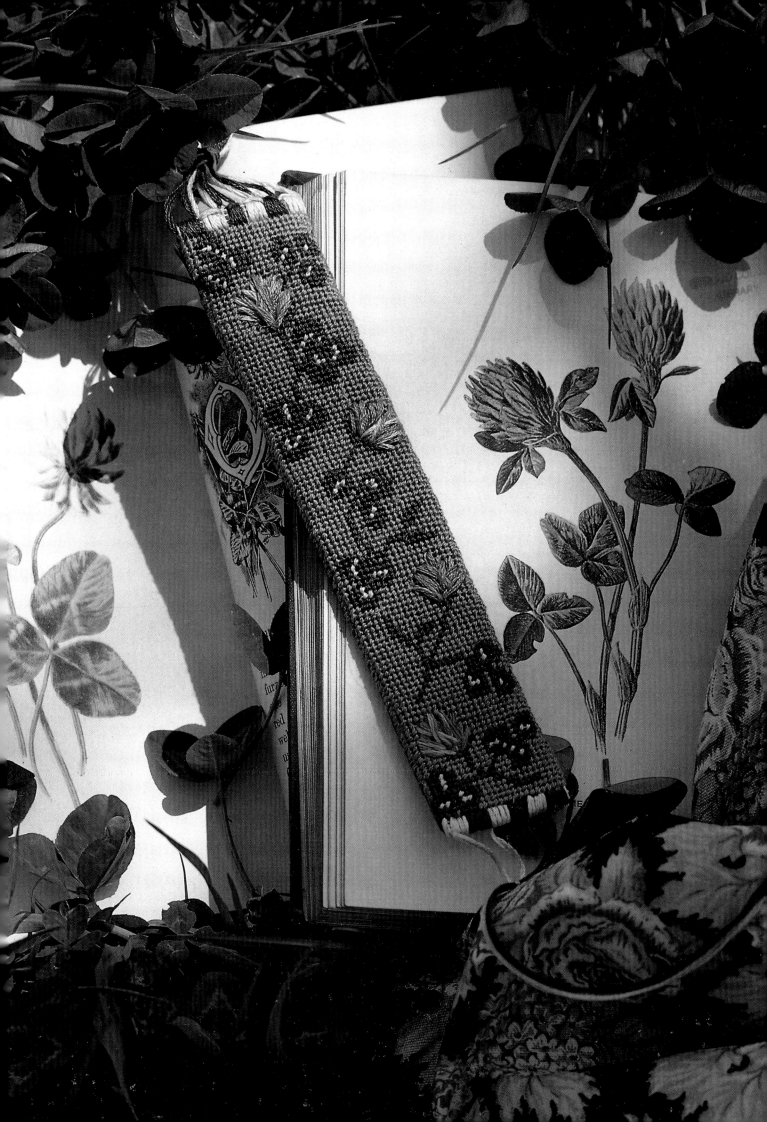

Red clover flowers taken as tea are good for the circulation and have a stimulant effect that soothes the nerves. Concentrated extract of red clover has been used as a plaster for the treatment of tumours. The fresh flowers may also be made into an ointment by simmering them in a base of olive oil and beeswax until all the properties are extracted. After straining, the salve should be put into airtight jars and used for sores, ulcers and spots.

The clover that is known as wood sorrel is held by many to be the original shamrock, although the plant used to celebrate St Patrick's day is, in fact, Dutch clover. The religious associations of shamrock and its adoption as the symbol of Ireland are credited to its use by the bringer of Christianity to that country. It is said that on his arrival St Patrick found the Irish confused about the Trinity, and he used a three-leaved clover to illustrate that, although it was but one leaf, it was, in fact, three leaves in one. The Irish then adopted the shamrock as their emblem, the three leaves being taken to represent the national virtues of love, heroism and wit.

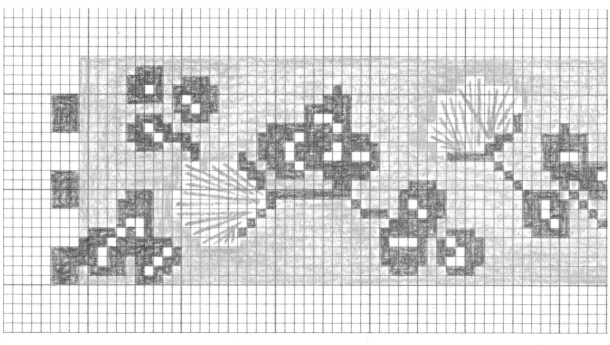

MATERIALS

1 piece of 18-mesh interlocked canvas, 4¾ × 9½in (12 × 24cm)

1 piece backing fabric, 2½ × 7½in (6.5 × 19cm)

Blunt-ended needle

Waterproof pen

Anchor stranded cotton – use four strands for all tent stitch areas and six strands for the clover flowers

- ▨ 1 skein olive (0846)
- ▨ 2 skeins green (0238)
- ▨ 1 skein shaded mauve (01208)
- ▨ 1 skein ecru (0590)

METHOD

Mark guidelines to position the chart in the centre of the canvas. Work the leaves and background areas from the chart in tent stitch, using four strands of cotton. Work a fan of equal-length straight stitches over the flowerhead area, then work another fan of smaller stitches on top; repeat the process until your flowers appear to be three-dimensional. Fold the waste canvas vertically and tack it together at the centre back; fold and sew down the top and bottom waste canvas, leaving a ridge of ¼in (5mm). Using six strands of alternate ecru and olive cotton, oversew the ridges in stripes of four stitches, leaving four ends (two of each colour), approximately 7½in (19cm) long, at the bottom of the bookmark and 12 ends, approximately 2in (5cm) long, at the top. Knot the top ends 1in (2.5cm) above the canvas and trim. Knot the bottom ends 1in (2.5cm) from the bottom of the canvas and again at the end of the lengths of cotton. Fold in the edges of the backing fabric and press. Stitch it neatly all around the back of the canvas.

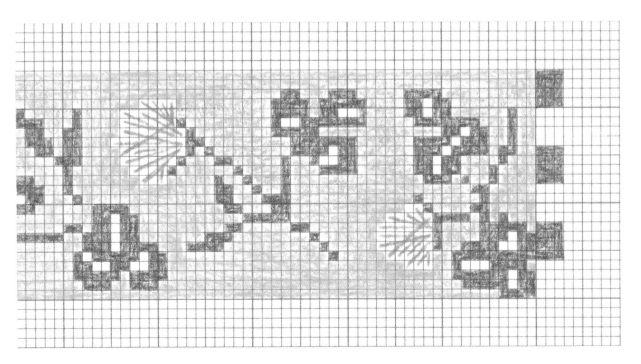

DANDELION CLOCK

Make yourself a real dandelion clock! I have used 10-mesh canvas and worked the design in three strands of Paterna tapestry wool. The quartz clock mechanism can be bought from any good clock dealer very cheaply, and there is a choice of hands – either gothic black or ornate gold (see Stockists, page 110). The image is worked in half-cross stitch and the centre hole is bound off in buttonhole stitch.

The botanical name *Taraxacum officinale* derives from the Greek words *taraxos* (disorder) and *akos* (remedy), in recognition of the plant's value in herbal remedies. The common English name, dandelion, is derived, it is said, from the French *dent de lion* because its leaves resemble lions' teeth. The French also call this weed *pissenlit*, and its medicinal use as a diuretic is well documented. The leaves are rich in vitamin A, which aids good vision and helps to develop strong bones and teeth.

The glorious golden flowers are a common sight in gardens and verges from March to July, and although gardeners today may despair, the dandelion was once a cultivated plant, sharing its ancestry with the chrysanthemum, dahlia and sun-flower. In addition to its medicinal properties, the dandelion has a long and distinguished culinary history. The leaves taste delicious in salads, while the flowers can be used to make tea and wine. The roasted root produces a smooth, mild and healthy coffee substitute.

The dandelion is now a free and wild spirit and a well-known friend to children who can often be found blowing its gossamer tendrils into the sky in a game of 'tell the time'.

COMMON NAMES – blowball, milk gowan, priest's crown and swine's snout.

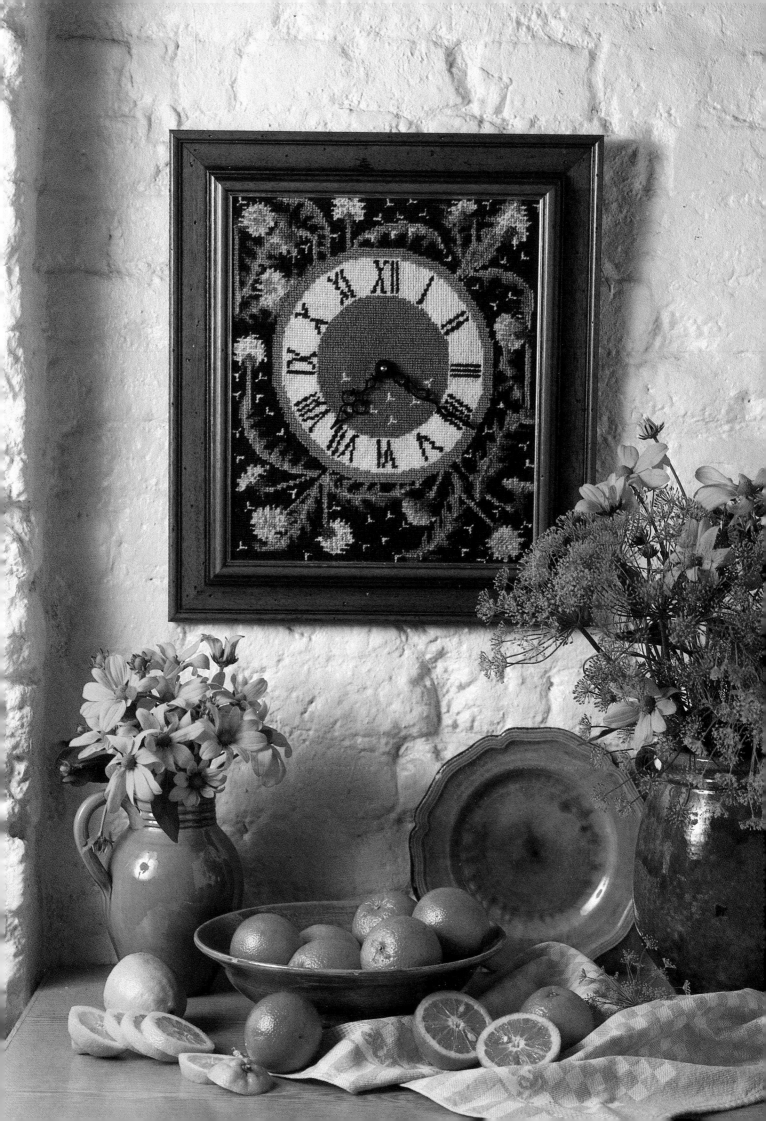

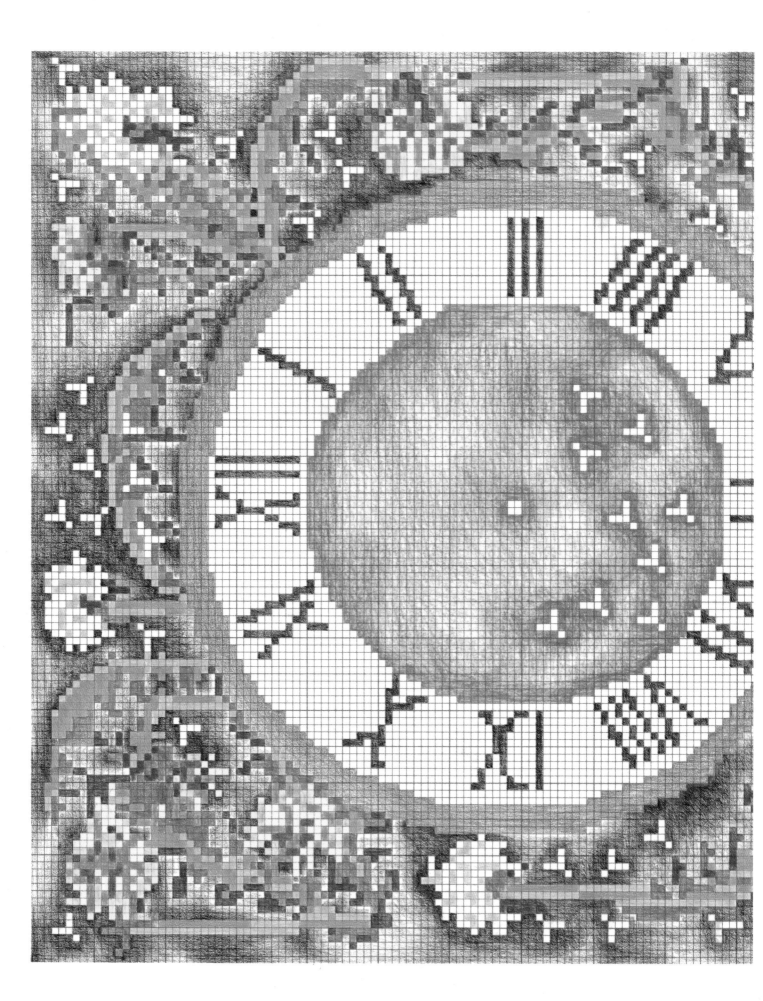

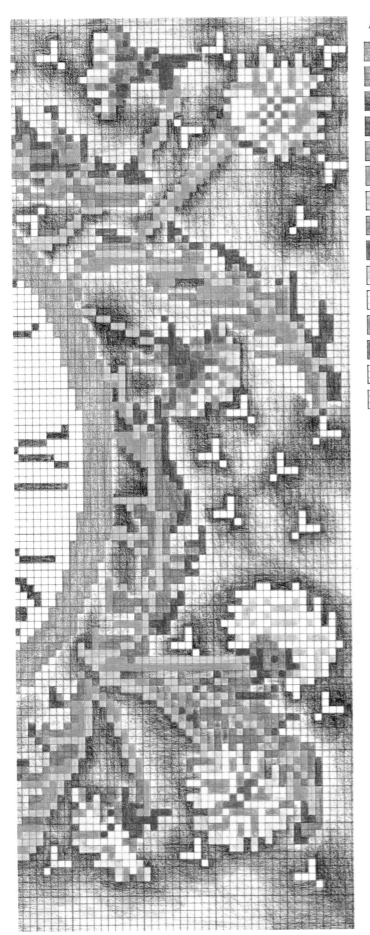

Key

- 3 skeins rose (404)
- 3 skeins federal blue (504)
- 9 skeins charcoal (221)
- 1 skein loden green (691)
- 2 skeins loden green (692)
- 1 skein loden green (693)
- 1 skein loden green (694)
- 1 skein khaki (642)
- 1 skein khaki (641)
- 1 skein daffodil (761)
- 1 skein sunny yellow (773)
- 1 skein sunny yellow (771)
- 1 skein marigold (802)
- 6 skeins cream (261)
- 1 skein khaki (644)

*. . . very effectuall for the obstructions
of the liver, gall and spleene, and the
diseases that arise from them, as the
jaundise and hypochondriacal passion.*
JOHN PARKINSON (1567–1650),
APOTHECARY TO JAMES I

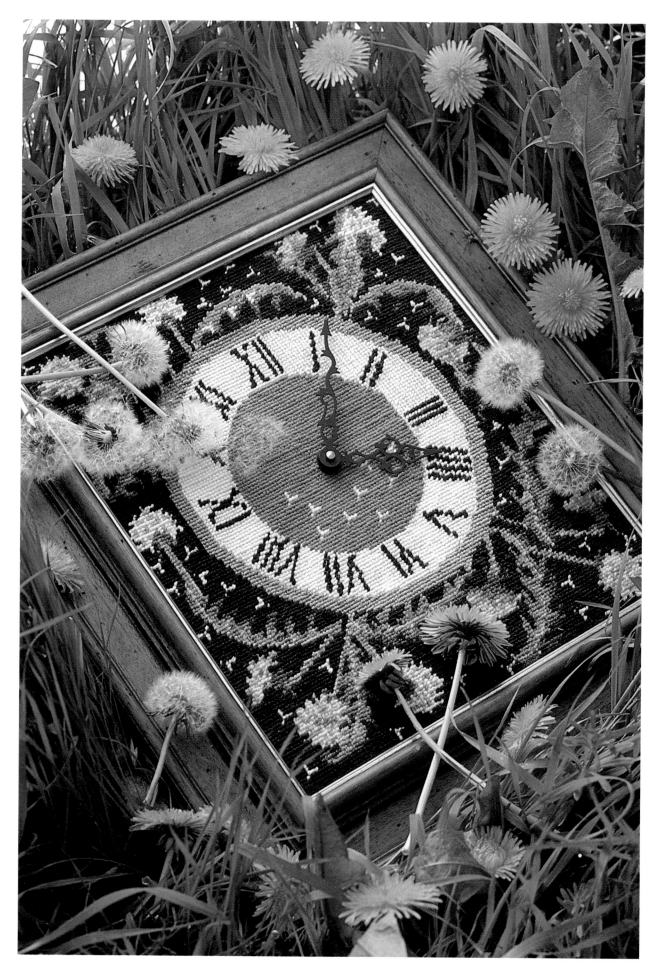

20 · CLOCK

MATERIALS

1 piece of 10-mesh interlocked canvas,
 16 × 18in (41 × 46cm)
1 sheet of stiff cardboard, 12¼ × 14in
 (31 × 35.5cm)
Blunt-ended needle
Waterproof pen
Rubber-based adhesive or double-sided
 tape
Paterna Persian tapestry wool – use
 three strands throughout
 9 skeins charcoal (221)
 6 skeins cream (261)
 3 skeins federal blue (504)
 3 skeins rose (404)
 2 skeins loden green (692)
 1 skein each loden green (691, 693
 and 694)
 1 skein each khaki (641, 642 and
 644)
 1 skein daffodil (761)
 1 skein each sunny yellow (771 and
 773)
 1 skein marigold (802)

METHOD

Before you start, you might find it
useful to outline the position of the
clock on the canvas with a waterproof
pen. Begin working the chart from the
bottom right-hand corner, leaving 2in
(5cm) of canvas below and to the right
of your first stitch. Work in half-cross
stitch until the chart is complete,
leaving the centre of the clock face
blank as outlined. Snip the cross
threads at the centre, and bind off in
charcoal using buttonhole stitch. If you
have not used a frame, block the canvas
(see Techniques, page 104). Place the
card behind the tapestry and make a
hole to correspond with the hole in the
centre of the clock. Attach the tapestry
to the board using either a rubber-
based adhesive or strong, double-sided
tape, snipping the waste canvas at the
corners to ensure a neat, flat finish.
Attach the clock mechanism to the
hands through the centre hole.

*The decoction of the whole plant is
beneficial to sufferers from jaundice.
Magicians say that if a person rub
himself all over with it, he will
everywhere be welcome and obtain what
he wishes.*
P.A. MATIOLI (MATTHIOLUS),
SIXTEENTH CENTURY

FORGET-ME-NOT PICTURE FRAME

A photograph frame for your true love! To make a frame approximately 7½ × 9½in (19 × 24cm) I have used 14-mesh canvas and worked the design in six strands of Anchor stranded cotton. You can adjust the size of the frame by changing the mesh size, and you could work in wool if you prefer. The design is worked in half-cross stitch and you can use satin stitch to embroider a name in the panel at the bottom.

There are many myths and legends surrounding the forget-me-not, *Myosotis arvensis*, and how it got its name. One tradition suggests that a young man, walking beside the Danube with his sweetheart, saw the pretty blue flowers and jumped into the river to pick them for her. On his way back to the bank he was seized with cramp and, as the current swept him over a waterfall, he threw the bouquet to his love crying 'forget me not'. She never did forget him, wearing the flowers in her hair until her own death.

Another story has it that when Adam named all the plants in Eden he overlooked the forget-me-not because it was so small. Later he walked through the garden calling all the flowers by name to find if they were accepted, and each plant bowed and whispered its assent. Suddenly a small voice at his feet asked, 'By what name am I called Adam?' and, looking down, Adam saw the flower peeping shyly from a shadow. Struck with its beauty and his own forgetfulness, he answered, 'As I forgot you before, let me name you in a way to show I shall remember you again: You shall be "forget-me-not".'

While he was in exile, Henry IV of England adopted the forget-me-not as his emblem, with the motto 'Remember Me'.

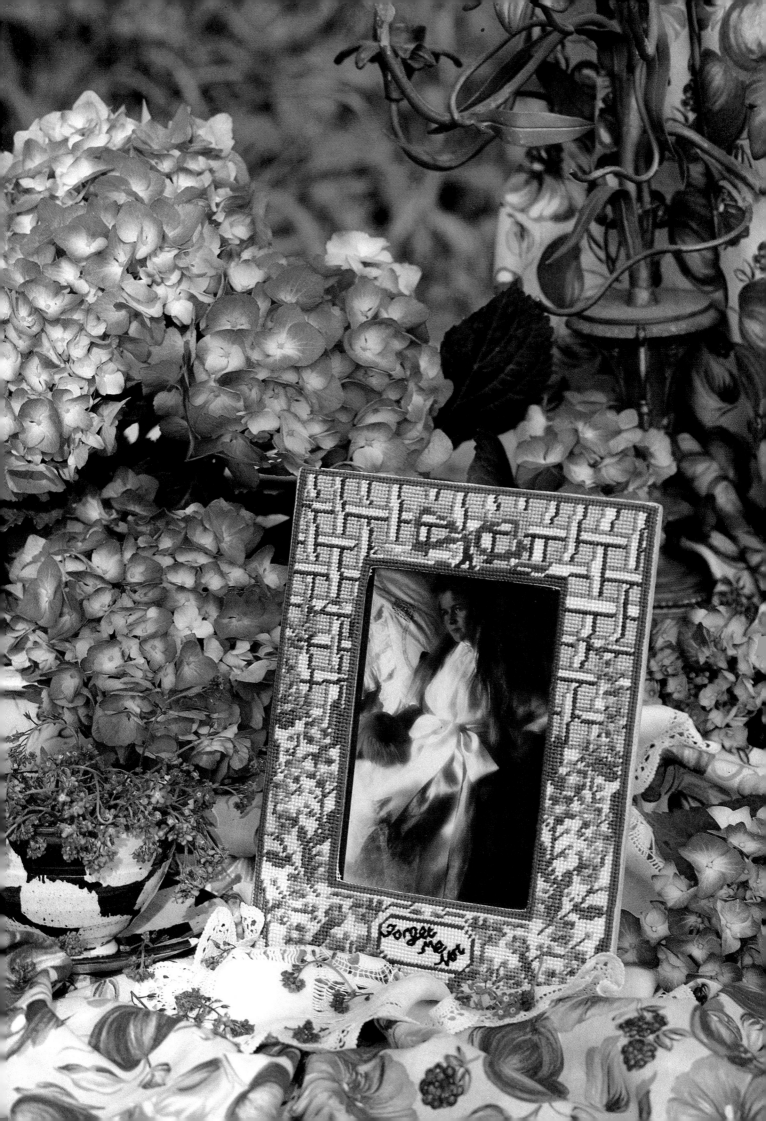

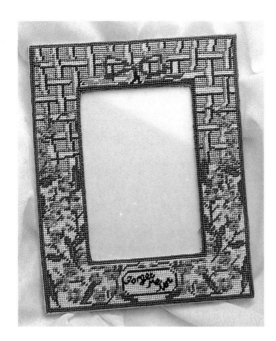

MATERIALS

1 piece of 14-mesh interlocked canvas, 14 × 21½in (36.5 × 54.5cm)

2 sheets of stiff cardboard measuring exactly the same as the finished work

1 piece of acetate to fit the centre of the frame, allowing 1in (2.5cm) overlap all round

Blunt- and sharp-ended needles

Craft knife

Rubber-based glue

Waterproof pen

Anchor stranded cotton – use six strands throughout

- 1 skein pink (085)
- 1 skein mauve (087)
- 1 skein dark mauve (089)
- 1 skein pale blue (0129)
- 2 skeins blue (0131)
- 1 skein yellow (0289)
- 3 skeins white (01)
- 1 skein dark green (0258)
- 1 skein light green (0256)
- 1 skein charcoal (0922)
- 1 skein grey (0849)
- 2 skeins light grey (0274)

METHOD

Leaving 3in (7.5cm) on each side, draw the outline of the frame on the canvas with a waterproof pen. Using half-cross stitch, work all borders in blue, then work the flower pattern, bow, trellis, panel and background. Using a sharp needle and the colour of your choice, embroider a name in satin stitch. If you have not used a frame, block the canvas (see Techniques, page 104).

Using a craft knife, cut an oblong of card to the size of your finished work, then cut out the centre panel. Rule diagonal lines from corner to corner on the blank central panel of your canvas and cut across these lines, taking care not to cut the corner stitches. Stretch the canvas around the frame (trimming off any excess waste canvas), and secure it to the frame with a rubber-based adhesive.

Lay the work face down on a clean surface and glue the acetate sheet to the back of the centre panel. Cut a second sheet of card to the finished size of the frame and glue it to the back, making sure that the edges only are stuck together and leaving the top open so that you can slide in your photograph. Cut a triangular support from some spare card, and carefully score it about 1in (2.5cm) down from the top to form a hinge. Stick the top section securely to the back of the frame.

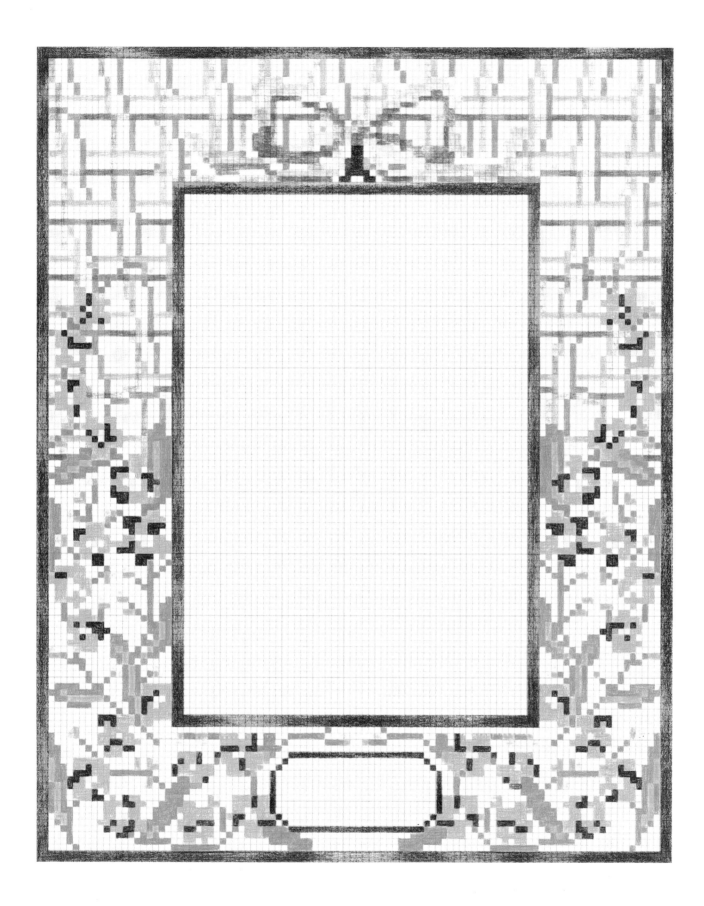

FOXGLOVE, BLUEBELL AND TANSY CARDS

Show you really care by taking the trouble to stitch your own greetings cards on pieces of waste canvas. Ready-cut cards are available from craft shops or through our mail order service (see Suppliers, page 110), and you can, of course, cut out your own greetings cards from coloured card or paper, folded horizontally into three sections. I have used 18-mesh canvas and four strands of Anchor stranded cotton, but wool would work just as well.

FOXGLOVE

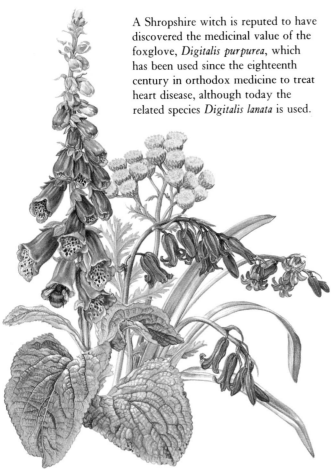

A Shropshire witch is reputed to have discovered the medicinal value of the foxglove, *Digitalis purpurea*, which has been used since the eighteenth century in orthodox medicine to treat heart disease, although today the related species *Digitalis lanata* is used.

Foxgloves have long been associated with fairies, and the name foxglove is a corruption of the words 'folk's glove'. They are also known as fairies' petticoats, fairy caps and fairies' dresses. It is rumoured that if you see a foxglove bending over, there may well be a fairy hiding in one of the bells. The Norwegian name for the plant is *revbielde* (fox-bell), and this is the only foreign name that alludes to the fox, although there is a northern legend that bad fairies gave these flowers to the fox so he could put them on his toes to soften his tread when he prowled among the roosts.

The word *Digitalis* means 'finger length', and this name is said to have been given to the flower by the German botanist Leonard Fuchs in his *Herbal*, which was published in 1542. The earliest use of the name foxglove – *foxes golfa* – is found in a plant list compiled in the fourteenth century during the reign of Edward III. In Scotland the plant is called bloody fingers and dead men's bells since, although it is widely used in herbal cures, excessive doses are poisonous. No one should attempt to try it for themselves.

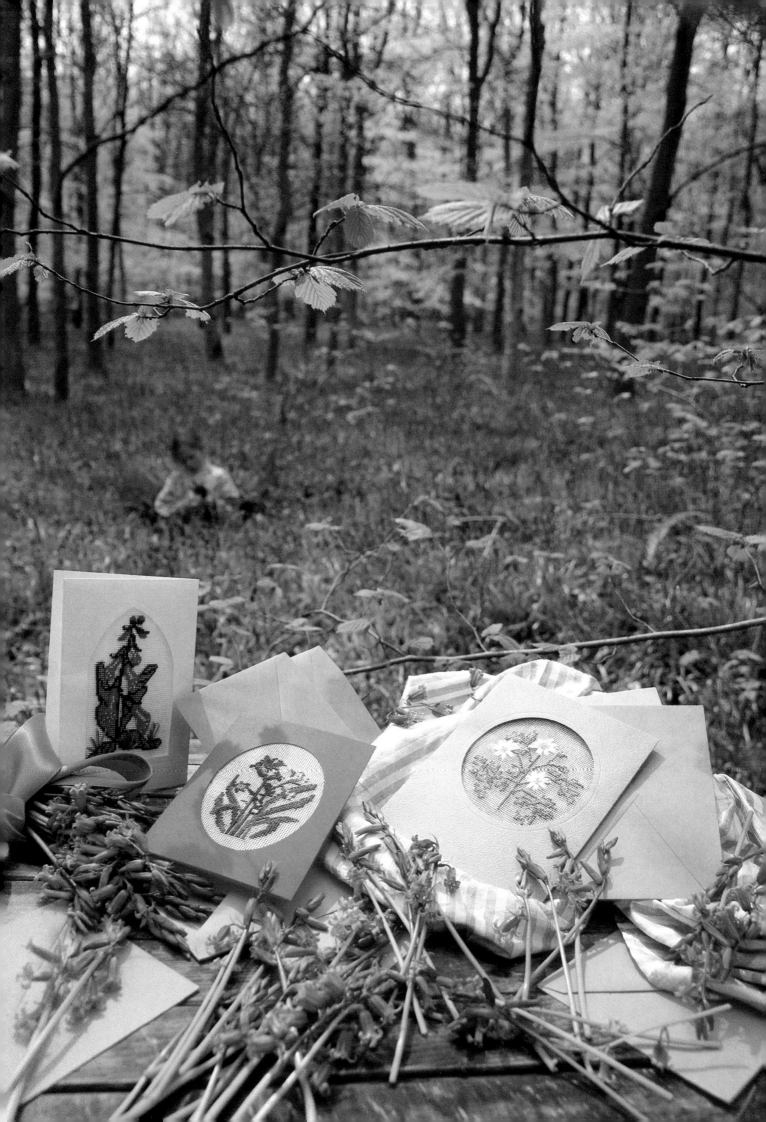

BLUEBELL

No childhood can be complete without a vision of woods in May, carpeted thickly with bluebells.

Linnaeus first named the bluebell *Hyacinthus*, and the Ancients associated the flower with grief and mourning. Hyacinthus was a charming youth loved by both Apollo and Zephyr, but Hyacinthus preferred the sun-god to the god of the west wind, who sought to be revenged. One day, when Apollo was playing quoits with the youth, a quoit (blown off its proper course by Zephyr) killed Hyacinthus, and the grief-stricken Apollo raised from his blood a purple flower on which the letters *Ai, Ai* were traced so that his cry of woe might for evermore exist on earth. As our own hyacinth has no trace of these mystic letters, our older botanists called it *Hyacinthus non-scriptus* (not written on).

Digging up bluebell bulbs for any purpose is illegal nowadays, even though recent research suggests that it is the trampling of leaves by heavy-footed sightseers that most threatens the plant's survival. Although the plant can survive without its flowers, if the leaves are crushed it dies for lack of food. A strong paper glue can be collected from home-grown bluebell bulbs by scraping the side with a knife. This produces a thick, sticky slime, which should be used straightaway. In the days when stiff ruffs were worn, this juice was used as a substitute for starch.

COMMON NAMES – auld man's bell, calverkeys, culverkeys, jacinth, link, ring-o'-bells and wood bells.

TANSY

The bright yellow flowers of *Tanacetum vulgare* are a common sight in our hedgerows and on wasteground. The common name, tansy, as well as the plant's generic name are probably derived from the Greek word *athanaton*, which means immortal, although it is not certain whether this alludes to the fact that the dried flowers are everlasting or to the fact that the gods are said to have given an infusion of the plant to Ganymede to make him immortal.

For centuries tansy was used to get rid of worms, and in aristocratic medieval communities tansy puddings were made for this purpose. Writing in his *Herball* in the sixteenth century, John Gerard noted: 'In the Spring time are made with the leaves here of newly sprung up, and with eggs, cakes of Tansies, which be pleasant to taste, and good for the stomacke. For if any bad humours cleave there unto, it doth perfectly concot them, and scowre them downewards.'

Tansy cakes became a part of many Easter traditions and were eaten symbolically on Easter Day to mark the end of Lent and to commemorate the bitter herbs eaten at the Jewish Passover.

On Easter Sunday be the pudding seen,
To which the tansy lends her sober green.

Tansy was once found in every cottage garden and was valued as a substitute for nutmeg and cinnamon, which were both very expensive spices. It was used to flavour custards, cakes, omelettes and freshwater fish, and in Ireland it was used in the making of sausages known as 'drisheens'.

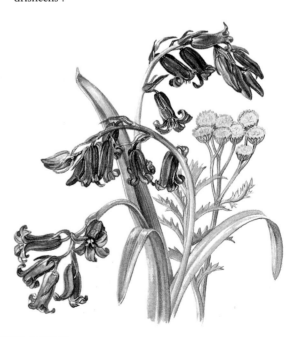

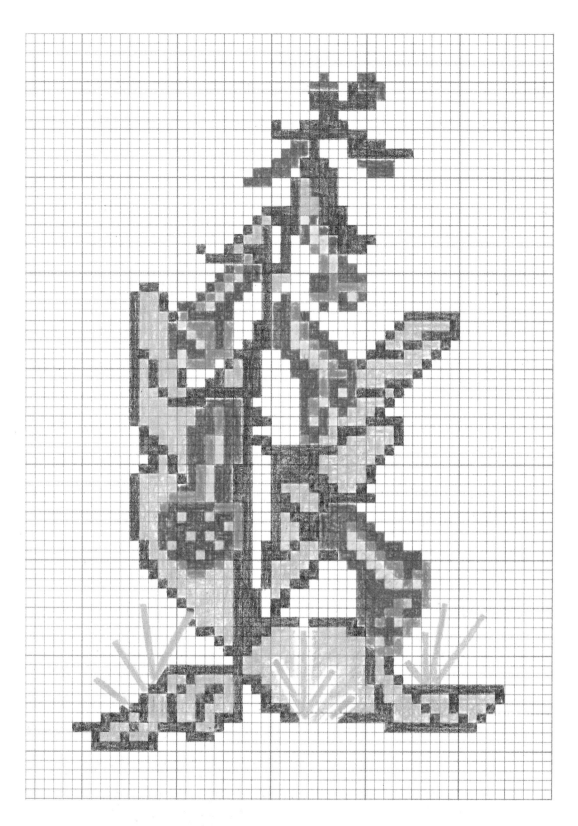

Foxglove key

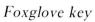 1 skein dark green (0269)

1 skein green (0256)

1 skein fuchsia (089)

1 skein pink (087)

1 skein beige (0852)

MATERIALS

1 piece of 18-mesh interlocked canvas,
 cut to size of card
Card
Blunt-ended needle
Rubber-based adhesive
Anchor stranded cotton – use four
 strands throughout

Bluebell key

■ 1 skein shaded blue (01210)

▦ shaded blue (01210)

▦ shaded blue (01210)

▦ shaded blue (01210)

■ 1 skein green (0227)

▦ 1 skein dark green (0923)

A TANSY
Take three pints of Cream, fourteen
New-laid-eggs (seven whites put away)
one pint of juyce of Spinage, six or seven
spoonfuls of juyce of Tansy, a Nutmeg
(or two) sliced small, half a pound of
sugar, and a little salt. Beat all these well
together, then fry it in a pan with no
more Butter than is necessary. When it is
enough, serve it up with the juyce of
Orange or slices of Limon upon it.
SIR KENELME DIGBIE, 1669

Tansy key

■ 1 skein green (0209)

▨ 1 skein light green (0207)

▦ 1 skein yellow (0290)

▦ 1 skein white (01)

METHOD

Centre the design on your canvas and
follow the chart of your choice,
working in tent stitch, half-cross stitch
or cross stitch. Add embroidery where
appropriate – the grass with the fox-
glove – in long stitch. Stick the
completed canvas to the inside fold of
the card with a rubber-based adhesive.

GARLIC AND CHIVE BOOK COVER

The instructions given here are for a cover that will fit a book measuring 10 × 8in (25.5 × 20cm), with a spine of 1½in (4cm). You can make the cover larger by increasing the size of the black centre panels or by adding to the size of the border. You can also change the mesh size of the canvas. Start by cutting the canvas to fit your book and adjust the design from there, remembering to centre the back panels.

CHIVES

The chive, *Allium schoenoprasum*, shares its generic name *Allium* with onions and garlic, while *schoenoprasum* is the Greek name for leek. The plant's origins can be traced back to the ancient Chinese, and chives were widely used throughout Asia and in Mediterranean countries well before the time of Christ. The Romans are credited with introducing the plant to Britain, where it was known as chibbole or chibbal, from *cipolla*, the Italian word for onion.

Nicholas Culpeper maintained that chives, when correctly prepared, made an 'excellent remedy for the stoppage of urine'. Eaten raw, they were believed to send vapours to the brain, disturbing sleep and affecting the eye-sight. Chives were said to protect people against general misfortune and 'the evil eye'.

They have many culinary uses and are widely used in salads and sauces.

A salad fit for a king
I sing;
With chives and marjoram, lemon
 thyme –
A crime
To leave out parsley and sprigs of
 mint –
A hint
Of sage and bay will crown the
 head
(in soup or stew)
Of the newly-wed!
 REGINALD ARKELL (1882–1959)

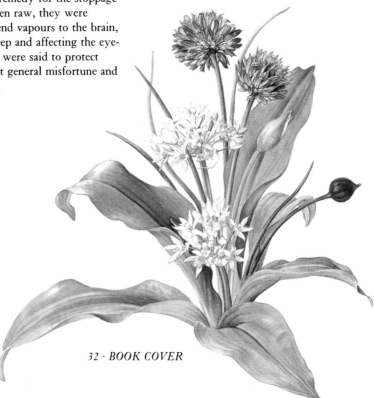

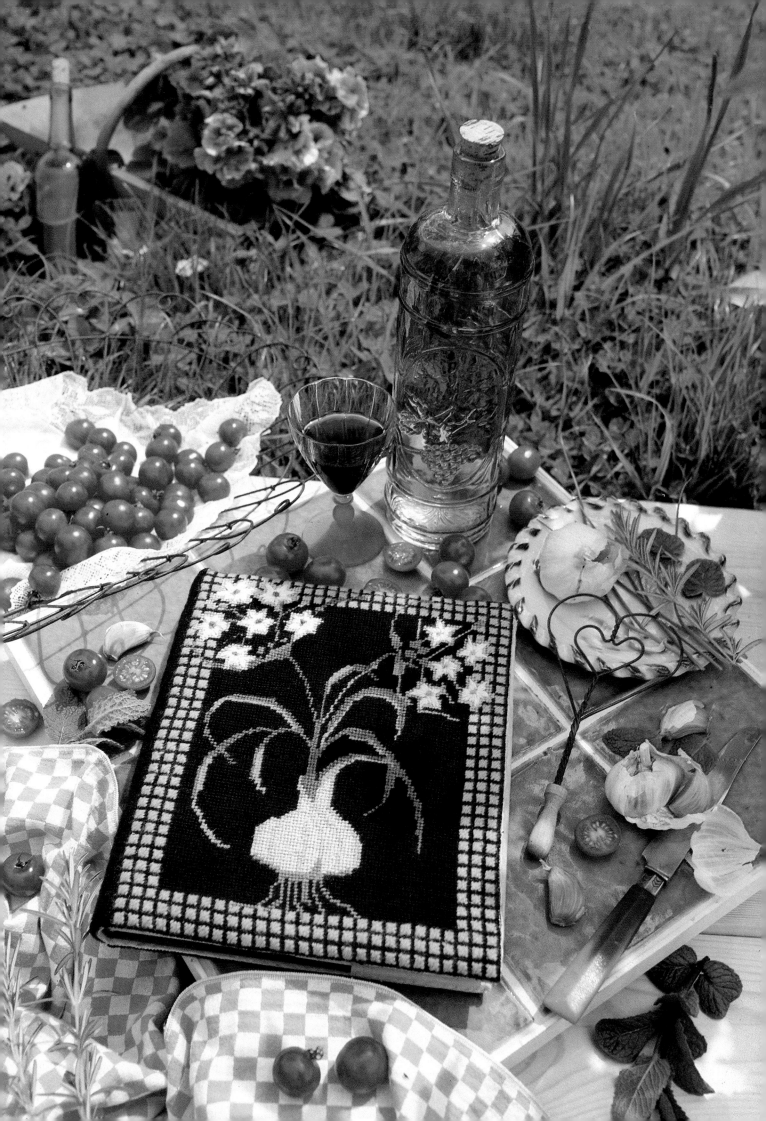

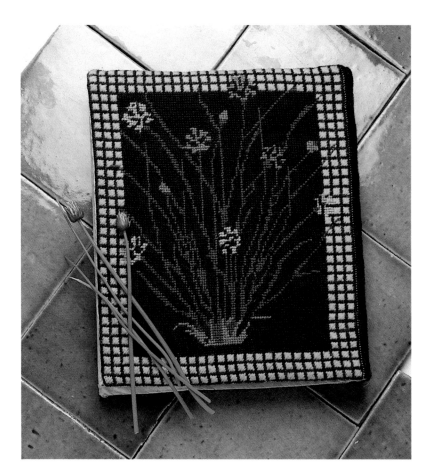

GARLIC

Garlic, *Allium sativum*, won favour with the Egyptians more than two thousand years before Christ, and it is known to have been cultivated in British gardens before 1540. It was sometimes known as poor man's treacle, being regarded by country folk as a 'treacle' or antidote to the bite of any poisonous snake.

The smell of new garlic bulbs was said to revive a sufferer from hysteria. It also has the reputation of increasing stamina, being given for that purpose by Cheops to the workmen building the Great Pyramid. Greek athletes and wrestlers chewed cloves of garlic to enhance their strength and courage. Modern research confirms that there is some truth in these early beliefs.

Garlic constituted the major ingredient in the Four Thieves' Vinegar, which was used so successfully in Marseilles as protection against the plague in 1772. The name originated from four thieves, who confessed that, while protected by the use of this aromatic vinegar, they had plundered the dead bodies of the victims of the plague with complete impunity.

During World War I garlic was widely used as an antiseptic, and in 1916 the British government asked for tons of the bulbs, offering one shilling (5p) for each pound. One pound in weight represented about twenty bulbs, which, when split into cloves and replanted, increased the crop and proved to be a very good investment.

Garlic has many, many culinary uses, and the fresh young leaves of wild garlic can be used in salads or added to soups and stews for flavouring. To eliminate garlicky breath, chew fresh parsley or cardamom seeds at the end of the meal.

The generic name *Allium* is the name of the onion family, and *sativum* means cultivated. One Mohammedan legend tells that: 'When Satan stepped out from the Garden of Eden after the fall of man, garlick sprang up from the spot where he placed his left foot, and onion from that where his right foot touched.' Food for thought!

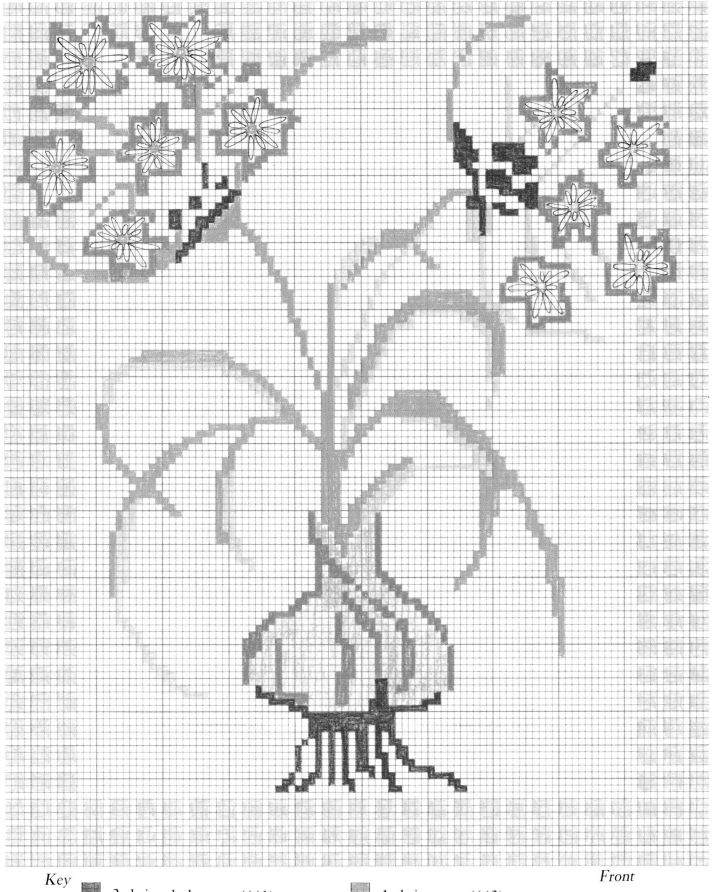

2 skeins dark green (661) 1 skein green (662)

1 skein mauve (322) 4 skeins lime green (671)

1 skein mauve (324) 14 skeins black (220)

1 skein mauve (325) 1 skein white (261)

MATERIALS

1 piece of 14-mesh interlocked canvas,
 30 × 14in (76 × 36cm)
20in (50cm) heavy cotton backing
 fabric
Strong sewing thread
Blunt- and sharp-ended needles
Waterproof pen
Paterna Persian tapestry wool – use
 two strands throughout

14 skeins black (220)
4 skeins lime green (671)
2 skeins dark green (661)
1 skein green (662)
1 skein mauve (322)
1 skein mauve (324)
1 skein mauve (325)
1 skein white (261)

METHOD

The white areas of the garlic flowers
are worked in satin stitch, and the
flower centres are worked as French
knots; the border is worked in Scottish
stitch, and the rest of the design is
worked in tent stitch.

Mark the position for the two charts,
centring the design on the canvas and
remembering to leave 1½in (4cm)
between the two floral panels for the
spine of the book. Mark the positions
for the inner panels, and then work the
chives and garlic and the background
area. Work the borders, outlining the
Scottish stitch in black and filling in
with lime green. When the chart is
complete, block your work (see
Techniques, page 104), trim off any
waste, turn the edges under your work
and press lightly. Cut a piece of lining
material that is 8in (20cm) wider than
the finished canvas, allowing ¾in
(2cm) turn-in at the top and bottom.
Hem the short ends neatly and place
the canvas on the strip, leaving 4in
(10cm) at each end for flaps. Stitch the
backing neatly to the canvas, fold in
the flaps and sew down the bottom and
top edges, so that you can slot the
front and back covers of your book
into the open short ends.

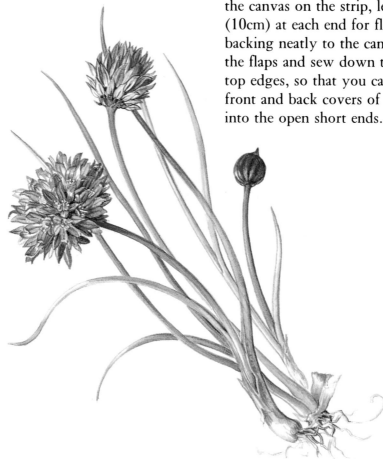

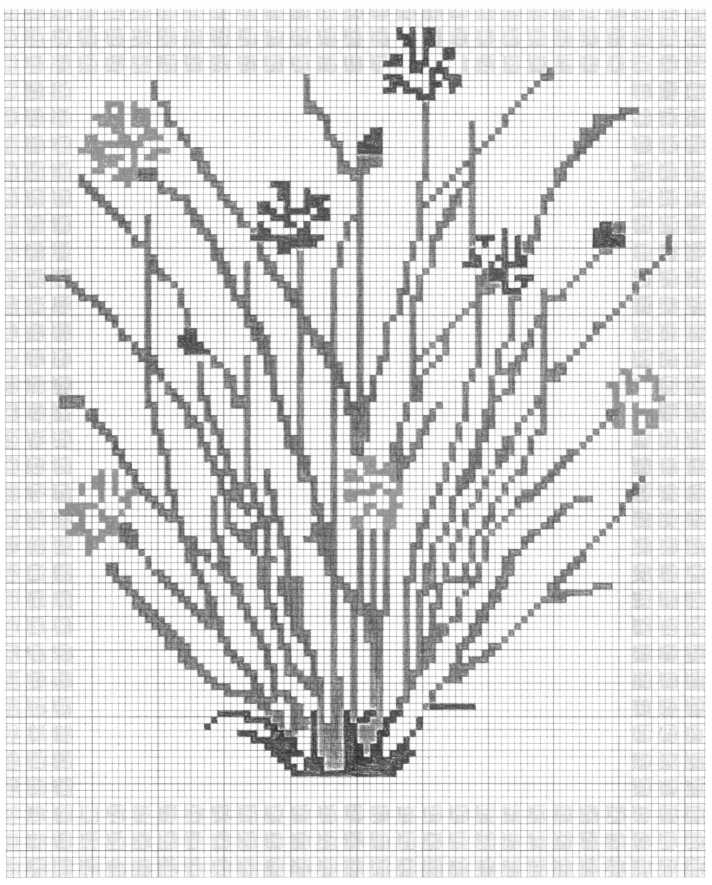

See key page 35 *Back*

HONEYSUCKLE FOOTSTOOL

We have used this square honeysuckle needlepoint as a footstool cover. The frame of the footstool is hand-carved in pine and is available by mail order either complete or unpolished in kit form (see Stockists, page 110). The needlepoint will also fit several of the other needlepoint stool frames that are readily available on the market. We have worked the needlepoint entirely in tent stitch but, for speed, you might like to work the flowers in a horizontal satin stitch. The finished size of the needlepoint is 13¼ × 13½in (34 × 34.5cm).

Honeysuckle, *Lonicera* × *americana*, was so named in the mistaken belief that bees extracted honey directly from the flower. The name *Lonicera* honours Adam Lonicer, the sixteenth-century physician and naturalist.

In Ancient Greece honeysuckle was regarded as an object of religious veneration second only to the lotus bud in importance. Although it is grown today mainly for its wonderful perfume, herbalists recommend the flowers as a cure for asthma, and a syrup concocted from the flowers was used for lung and digestive complaints and also as a gargle and for skin in-fections. The juice of the plant was taken as an antidote to snake bite – the infected area was bathed with water in which the plant had been boiled and the plant itself was then laid on the wound. The seeds and flowers, boiled and mixed with oil, provided a poultice for swellings, while a preparation of honeysuckle was also used as a contraceptive . . . but please don't count on it.

Honeysuckle is the birthday flower for 25 November, and astrologically it is under the dominion of Mercury. The flower symbolizes sweetness of disposition, bonds of love, constancy and domestic happiness, and in the language of flowers it means 'I will not answer hastily'.

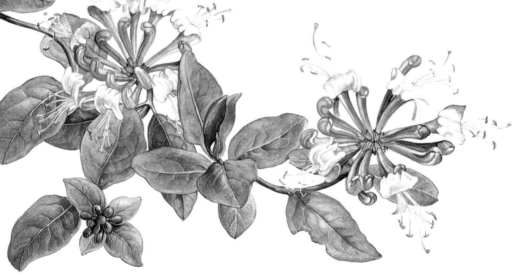

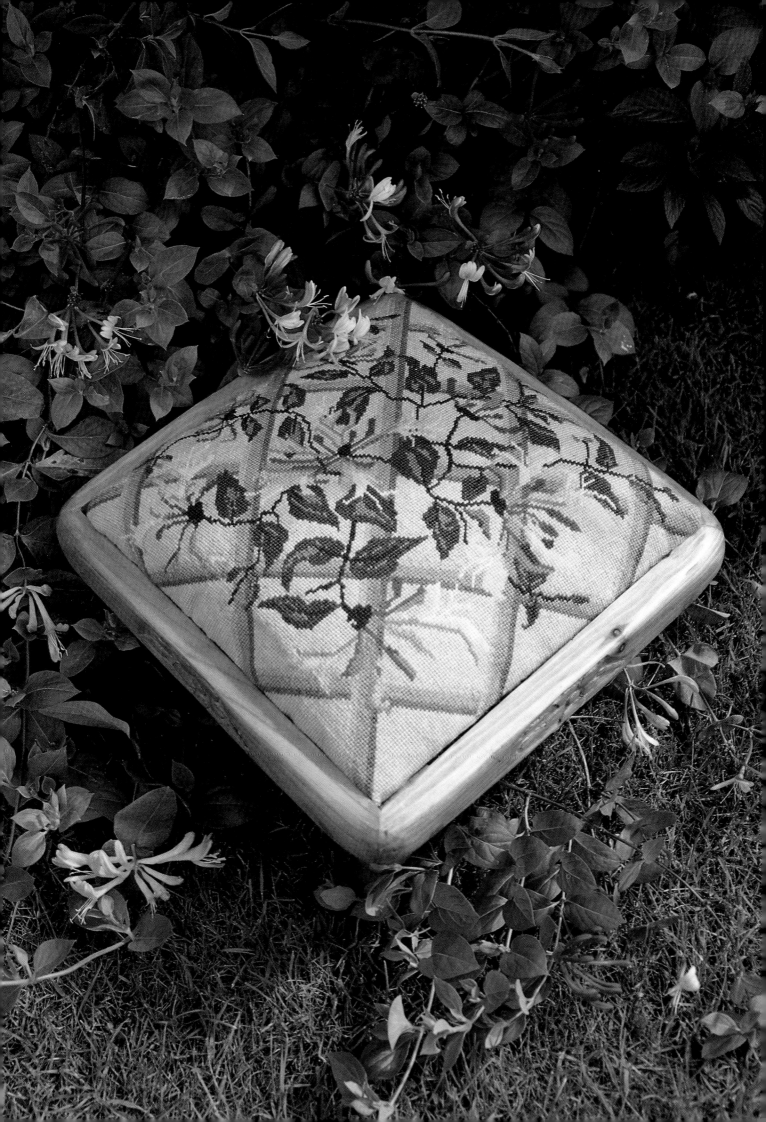

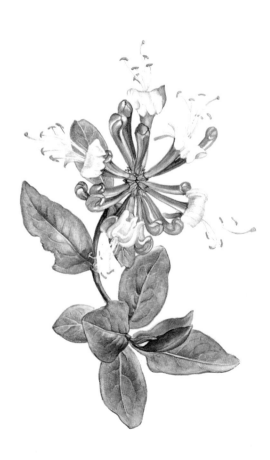

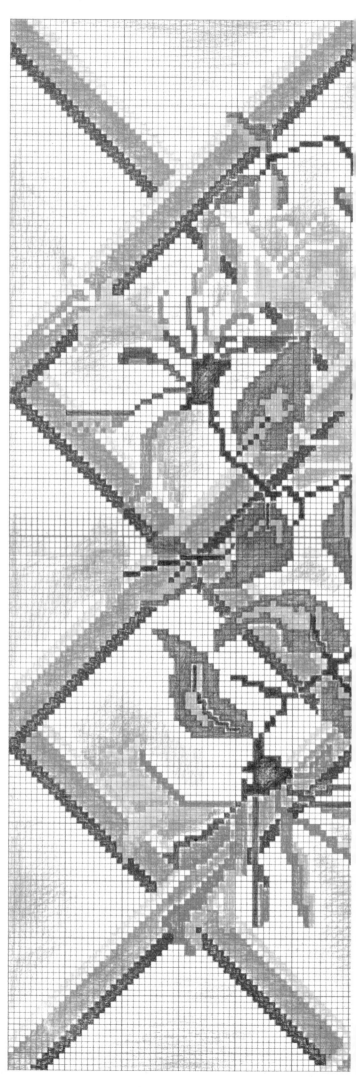

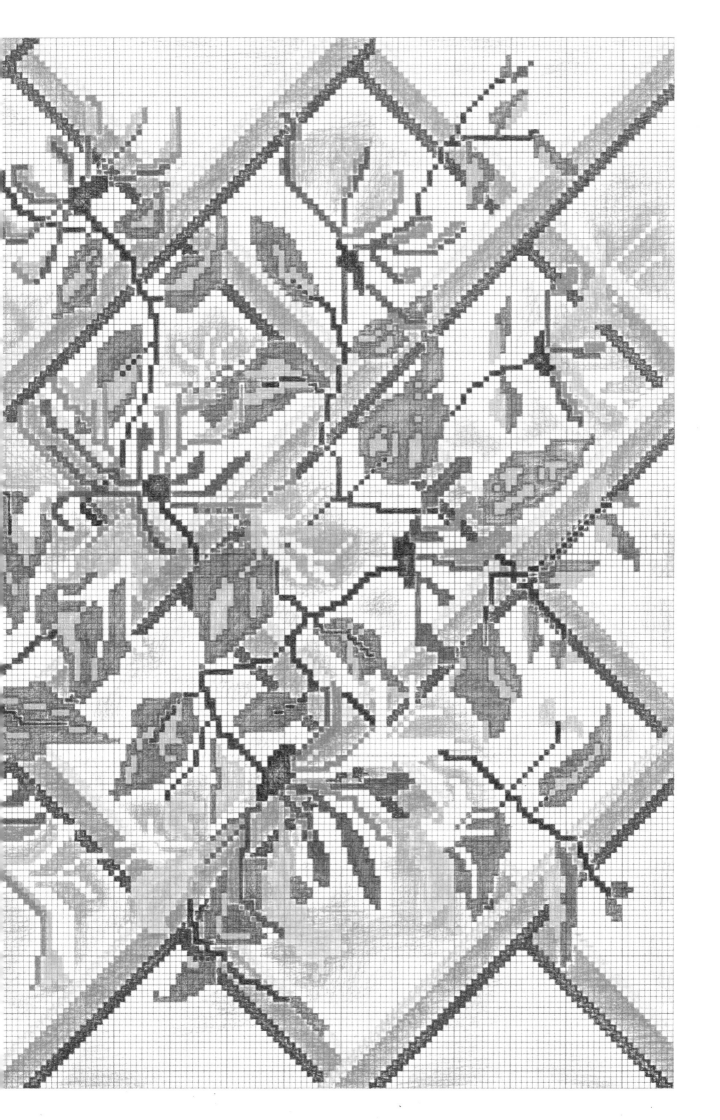

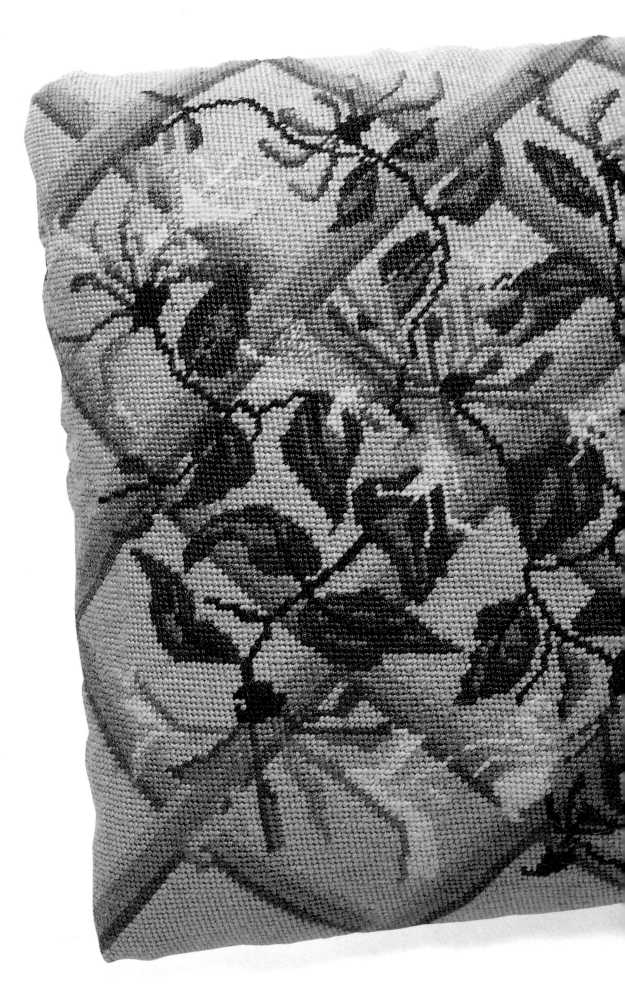

42 · FOOTSTOOL

MATERIALS

1 piece of 13-mesh interlocked canvas,
 18 × 18in (46 × 46cm)
Blunt-ended needle
Waterproof pen
Stool frame
Upholstery pins or staple gun
Paterna Persian tapestry wool – use
 two strands throughout
 1 skein light olive (652)
 3 skeins dark olive (650)
 2 skeins dark beige (462)
 4 skeins mid-beige (463)
 2 skeins beige (464)
 1 skein brown (422)
 1 skein rose (932)
 1 skein deep rose (931)
 1 skein peach (874)
 11 skeins grey-blue (344)
 1 skein dark yellow (773)
 1 skein light yellow (714)

METHOD

Mark guidelines on your canvas to
position the chart in the centre. Work
the design in tent stitch, using two
strands of wool throughout. You may
find it easiest to work the outlines of
the trellis first to ensure that the
flowers are correctly positioned. When
the needlepoint is complete, block it
carefully (see Techniques, page 104),
then stretch it on to your stool,
securing it under the seat with either
upholstery pins or staples.

3 June 1802 *The thrush is singing.*
There are I do believe a thousand Buds
on the honeysuckle tree all small and far
from blowing, save one that is retired
behind the twigs close to the wall and
snug as a Bird's nest.
 DOROTHY WORDSWORTH

LAVENDER HERB CUSHION

This lavender herb cushion is worked with a background of tent stitch, and the flowers, stems and leaves are embroidered on top, using straight stitch and French knots. I achieved the background pattern by spraying paint directly on to the canvas, using a paper doily as a stencil, so rather than follow my chart, you may like to try the same thing. Use a light-coloured, acrylic, water-based paint, diluted with water, and attach the doily to the canvas with masking tape. Leave it to dry overnight. Work the uncoloured areas in white and the painted canvas in a darker shade for the 'holes'. I have chosen to surround my cushion with a striped cotton fabric, which has been gathered into pleats and piped. A flat muslin circle stuffed with lavender is inserted together with the cushion pad so that it can be easily removed for washing or to replace the lavender when the need arises.

Lavender, *Lavandula spica*, is one of the most popular of all garden plants. The name Lavender is derived from the Latin *lavo* (I wash), and the flowers have been used to perfume soaps, bath water and linens for many hundreds of years. The plant is believed to have arrived in Britain during the mid–thirteenth century, but it was also a great favourite of the Romans and of the French. Charles VI of France had the cushions in his palace stuffed with the flowerheads to create a pleasant odour and to deter insects, particularly moths.

According to folklore, small poisonous snakes, asps, like to lie under lavender bushes, and so, in the language of flowers, lavender means 'distrust', echoing how people grew to view the plant. One tradition was that if lavender thrived in a garden, the daughter of the house would never marry; it is, therefore, associated with old maids' gardens.

Herbalists recommend two tea-spoonsful of the distilled water of the flowers to restore a lost voice and to calm the tremblings and passions of the heart, and a drop of the essential oil of lavender should be added to baby's bath to help it sleep. It is also an excellent cure for sunburn: simply tie a handful of lavender flowers in a small muslin bag and hang this to the hot tap while you run a bath.

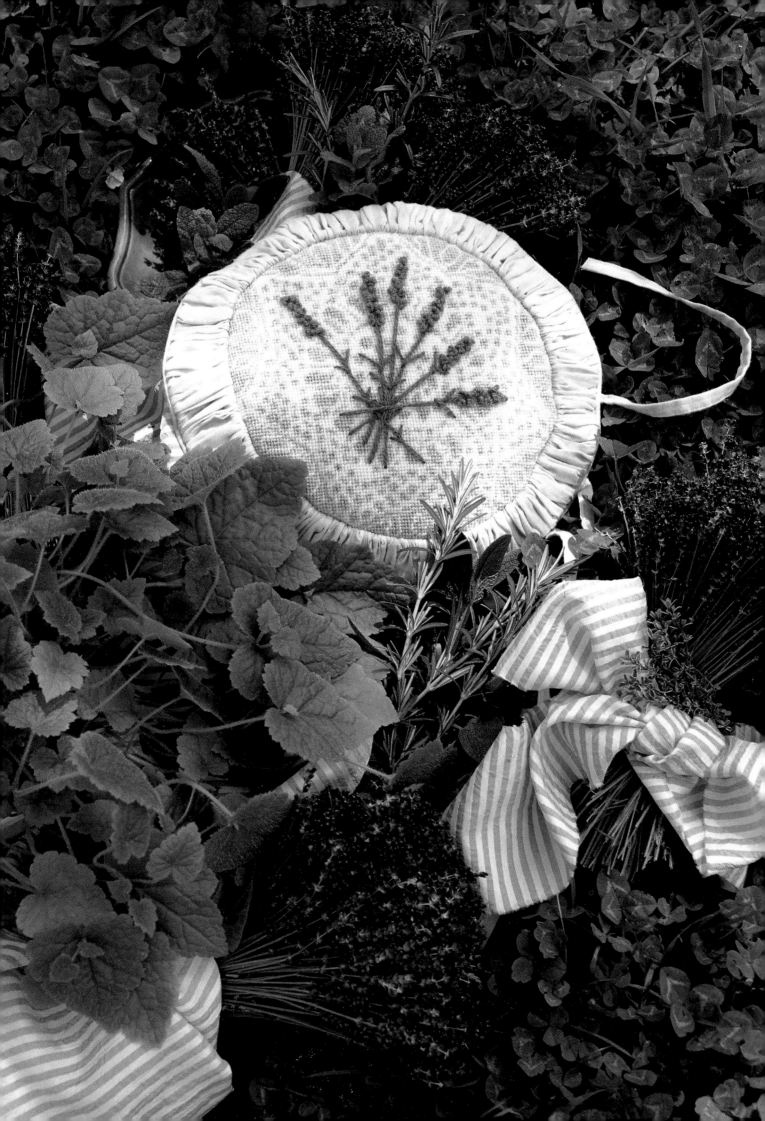

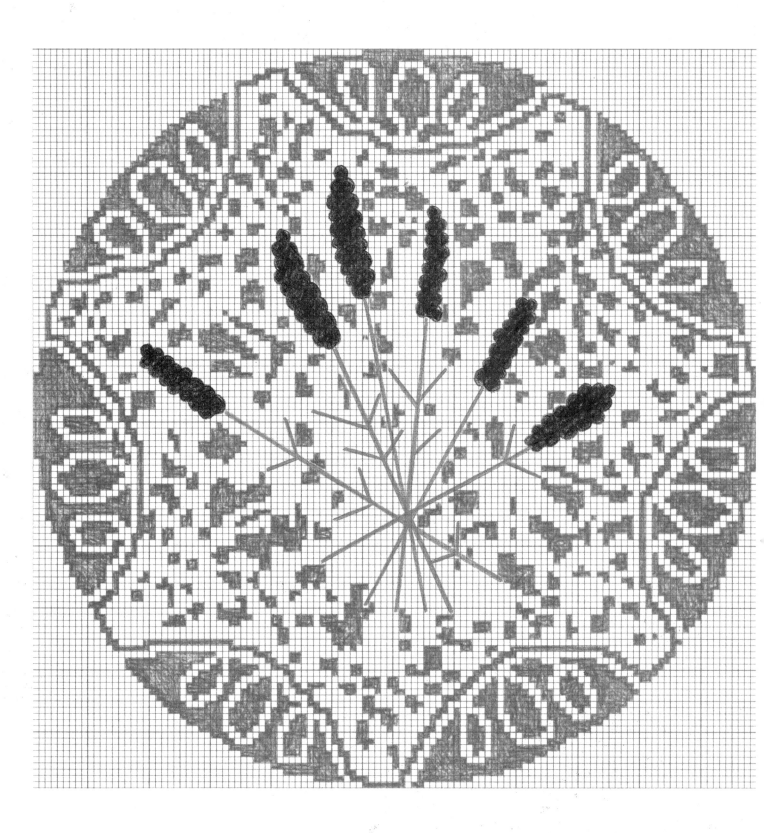

Lavender, sweet blooming Lavender
Six bunches a penny today.
Lavender, sweet blooming Lavender,
Ladies buy it while you may.

MATERIALS

1 piece of 13-mesh interlocked canvas,
 18 × 18in (46 × 46cm)
20in (50cm) cotton fabric, 1yd (1m)
 wide
1yd (1m) piping cord
20in (50cm) muslin
Dried lavender heads
Strong white sewing thread
Blunt- and sharp-ended needles
1 sheet of paper, 12 × 12in
 (31 × 31cm)
Waterproof pen
Circular cushion pad, 11in (28cm) in
 diameter
Paterna Persian tapestry wool – use
 two strands to work the background
 and three strands to embroider the
 bunches of lavender

1 skein mauve (332)

3 skeins lilac (334)

1 skein green (662)

4 skeins ecru (261)

METHOD

Leaving approximately 3in (8cm) of
waste canvas all around the design,
draw a circle on the canvas to mark the
approximate position of your work.
Work the entire background in tent
stitch, following the chart. Thread
three strands of green yarn into a
sharp-pointed needle and, with long
straight stitches, work the stems and
leaves of the flowers. Add the flower
heads in mauve using French knots.
When the work is complete, block
your canvas (see Techniques, page
104) and trim away the excess, leaving
1½in (4cm) of waste canvas all around
the design. Fold back the waste canvas
and sew it neatly to the back of your
work.

 Take the cotton fabric for the
surround and cut a strip approximately
3in (7.5cm) wide and 1yd (1m) long.

Cut a circle of paper approximately
11in (28cm) across. Gather the fabric
along one long edge and tack the other
long edge to the edge of the paper
circle to form even pleats. Sew the
gathered edge securely to your needle-
point. Cover the piping cord with
cotton fabric and sew to the outer edge
of the strip to form a circle. Tear away
the paper. Cut two semicircles of fabric
with a seam allowance of 1in (2.5cm)
at the curved edges and 3in (7.5cm) at
the straight edges. Turn the straight
edges back and hem them neatly. Sew
the semicircles to the back of the
cushion at the piped edge so that they
overlap vertically at the centre back.
Make four ties from the remaining
fabric and stitch these into position on
the back of the cushion. Cut two
circles of muslin, slightly smaller than
the cushion and join the edges, stuffing
it with lavender heads before you
finish sewing right round the edge.
Insert the muslin bag with the pad
inside the cushion. Make bows with
the ties.

LILY-OF-THE-VALLEY CUSHION

This basket of lilies-of-the-valley is mounted on a ready-made cushion cover made from moiré and purchased in a general department store (see Stockists, page 110). As the design is circular, it would look equally pretty centred and stitched on to a square cushion cover or backed on to a square of moiré and framed as a picture.

The sweetly perfumed lily-of-the-valley, *Convallaria majalis*, grows abundantly in cool woods and dales. In Germany it is known as little May bells, and in England it is sometimes called May flowers or May lilies, reflecting the time when the tiny white bells appear. It was also sometimes known as ladder to heaven, because the tiny bell-shaped flowers grow like steps up the stem. The generic name, *Convallaria*, derives from *convallis* (a valley).

Lily-of-the-valley is the symbol of May Day, and the flowers were traditionally grown by monks to decorate the altars on that day. An old English legend suggests that the lily-of-the-valley first flowered in a forest near Horsham, Sussex, where St Leonard slew a dragon that had been ravaging the countryside. The

lily was said to have sprung up from the drops of blood shed by this noble knight, and the forest, known today as St Leonard's Forest, is still thickly carpeted with the flowers.

In the 1600s the lily was cultivated in English gardens. The flowers were gathered and steeped in water to make a solution called *aqua aurea*, which Robert Louis Stevenson described in *Kidnapped*: 'It is good, ill or well, and whether man or woman. Likewise for sprains, rub it in; and for cholic, a great spoonful in the hour.'

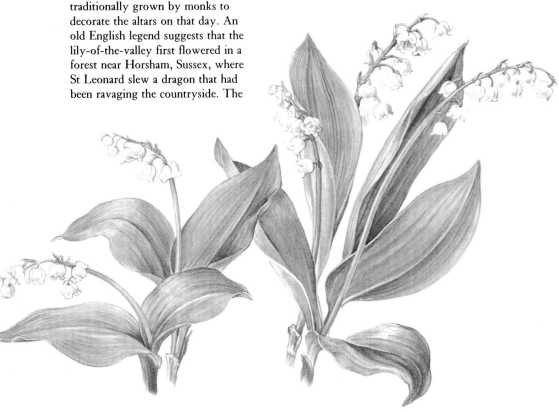

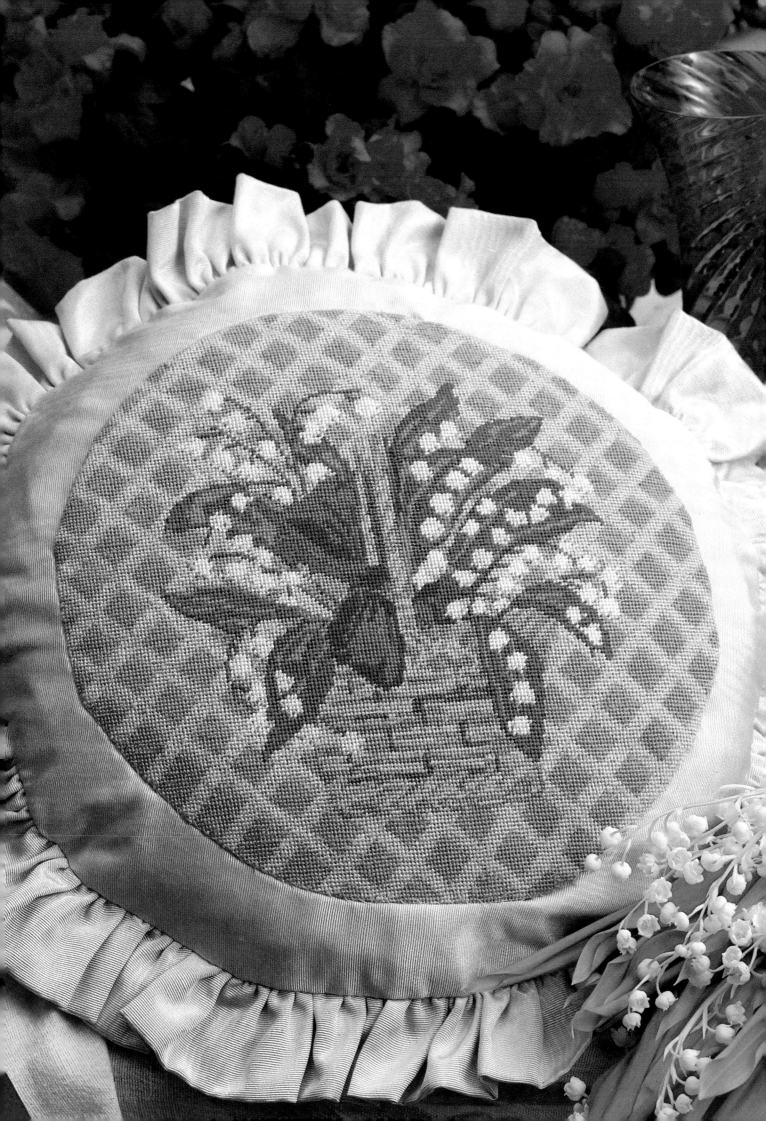

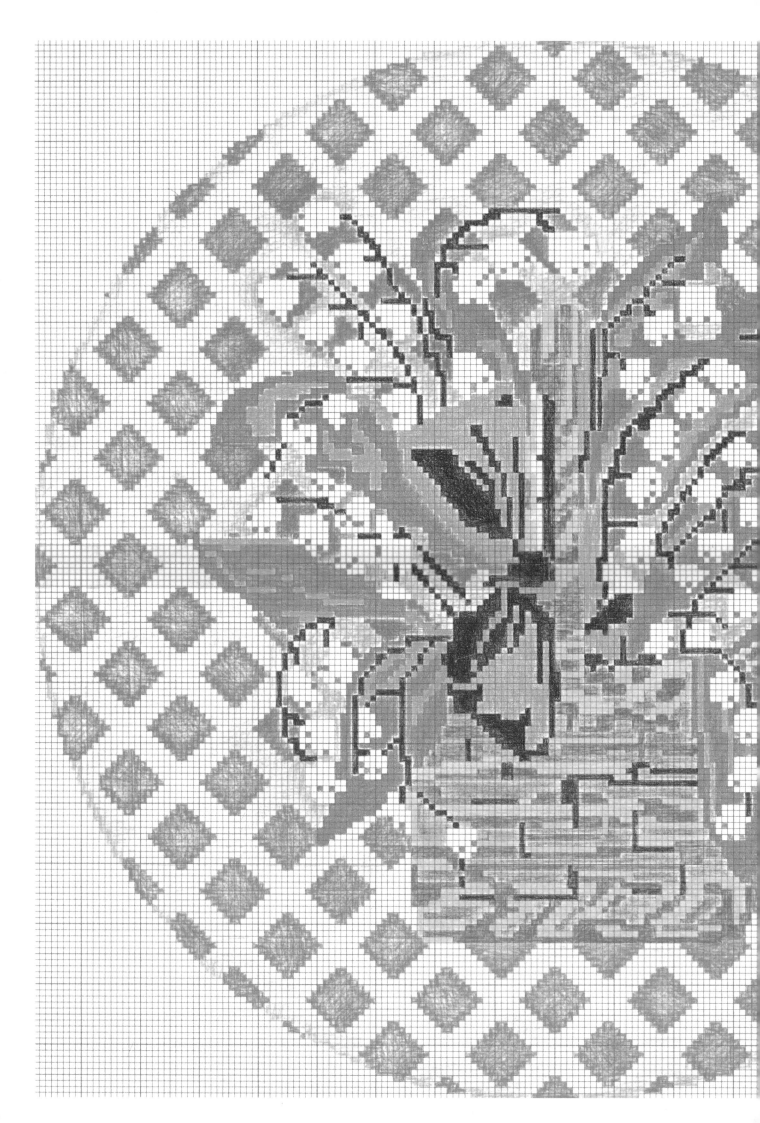

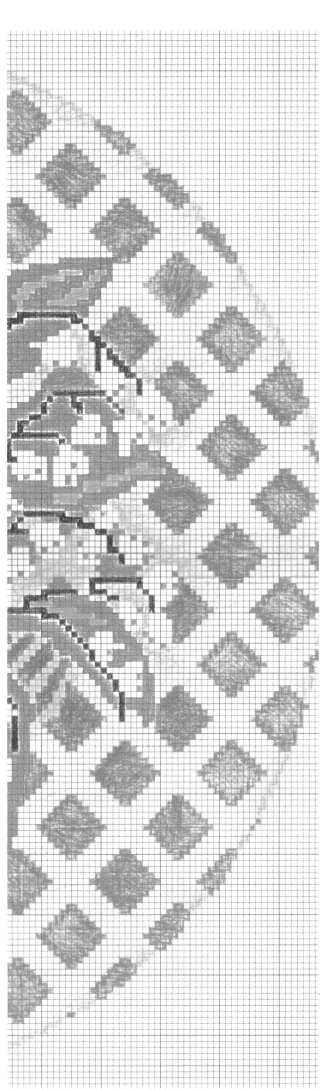

MATERIALS

1 piece of 18-mesh interlocked canvas,
 18 × 18in (46 × 46cm)
Blunt- and sharp-ended needles
Strong pink sewing thread
Waterproof pen
Cushion cover, approximately 14in
 (36cm) in diameter
Cushion pad to fit cover
Anchor stranded cotton – use four
 strands throughout

- 1 skein khaki (0856)
- 1 skein coffee (0373)
- 1 skein barley (0362)
- 1 skein stone (0886)
- 1 skein white (02)
- 6 skeins dark rose (0894)
- 6 skeins rose (0893)
- 1 skein dark blue (0119)
- 1 skein blue (0118)
- 2 skeins dark green (0230)
- 1 skein mid-green (0205)
- 1 skein slate (0849)

METHOD

Centre the design on the canvas and mark guidelines with a waterproof pen. Work the complete chart in tent stitch. If you start with the outline of the trellis you will find it easier to begin to position the flowers. When the work is complete, block the canvas (see Techniques, page 104) and trim it down, leaving a border of 1½in (4cm). Fold this waste canvas neatly under your work and stitch it down.

To stitch the canvas to the ready-made cushion cover, I used the unorthodox but perfectly satisfactory method of leaving the cushion pad in place and inserting a suitably sized dinner plate between the pad and the covering fabric. This kept the material taut while I stitched around the edge of the canvas, and it also prevented the stitches catching in the pad itself.

MARSHMALLOW CHAIR SEAT

The pine chair shown here is available by mail order (see Stockists, page 110). You can, of course, make up this design as a cushion or work it to fit any chair seat by altering the shape and size of the background area, but be sure to centre the floral design on your work. The finished needlepoint can simply be attached to the chair frame with upholstery tacks, but as you will have taken considerable time and trouble to produce the work, I would recommend that you take the canvas and chair to a professional upholsterer and have the job done properly!

The delicate pink flowers of the marshmallow, *Althea officinalis*, are found in marshes near the sea, chiefly in England and Ireland, during August and September. The name mallow is derived from the Old English *malwe* (soft), and the downy leaves were popularly used as a vegetable by the Romans, Ancient Egyptians and Chinese.

The root has a high mucilage content, and it was widely used for its curative powers, both as a poultice and as an expectorant for coughs. It is also an excellent conditioner for dry hair: soak the crushed root in cold water for eight hours, strain and use the liquid as a hair rinse. Alternatively, use the liquid for chapped hands, dry skin and sunburn.

The original marshmallow sweets were made by boiling slices of the root in sugar water to create a soothing sweet paste. The traditional recipe requires the following ingredients:

- 2oz (50g) dried, powdered marshmallow root
- 14oz (400g) caster sugar
- 1 tsp (5ml) gum tragacanth (available from chemists)
- 2½ tbsp orange flower water

Mix the root and sugar together. Stir the gum tragacanth into 2 tbsp of orange flower water, add the liquid to the powders and stir. Use the remaining orange flower water to bind the mixture together to form little balls, roll them into shape and leave to dry.

Marshmallow is the birthday flower for 5 February, and it symbolizes bachelorhood, beneficence and consent.

COMMON NAMES – cheeses, *guimauve* (French), mallards, mauls, mortification root and schloss tea.

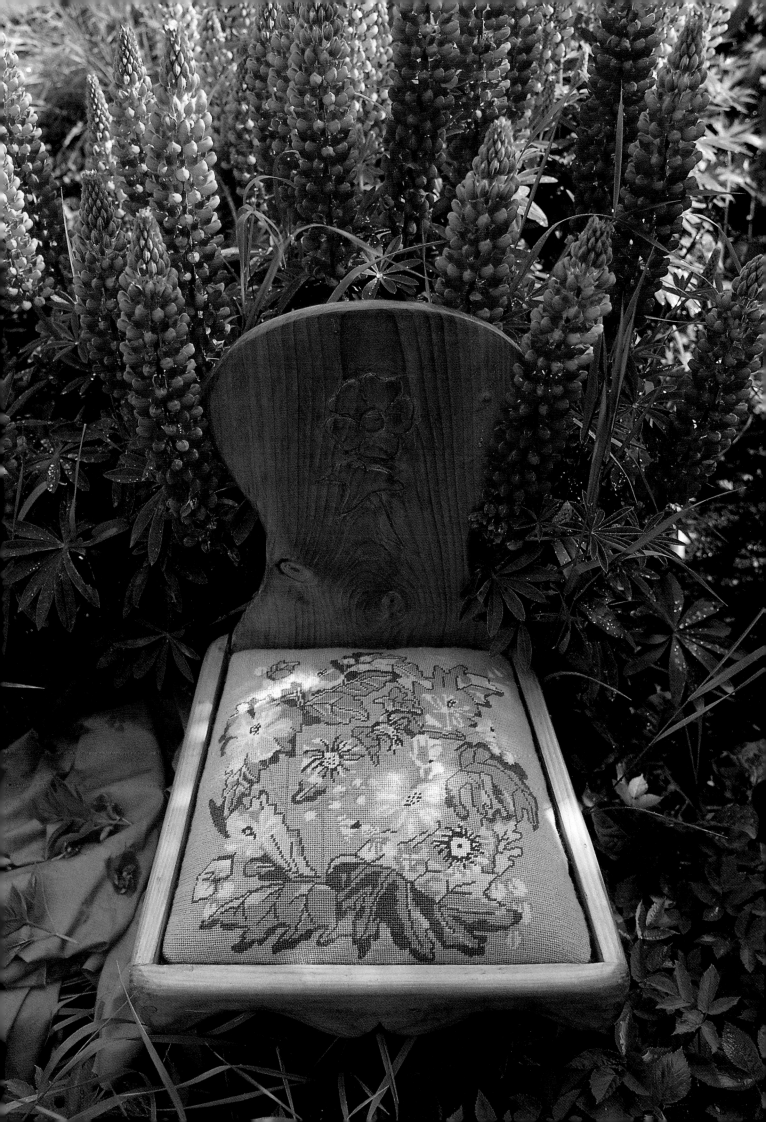

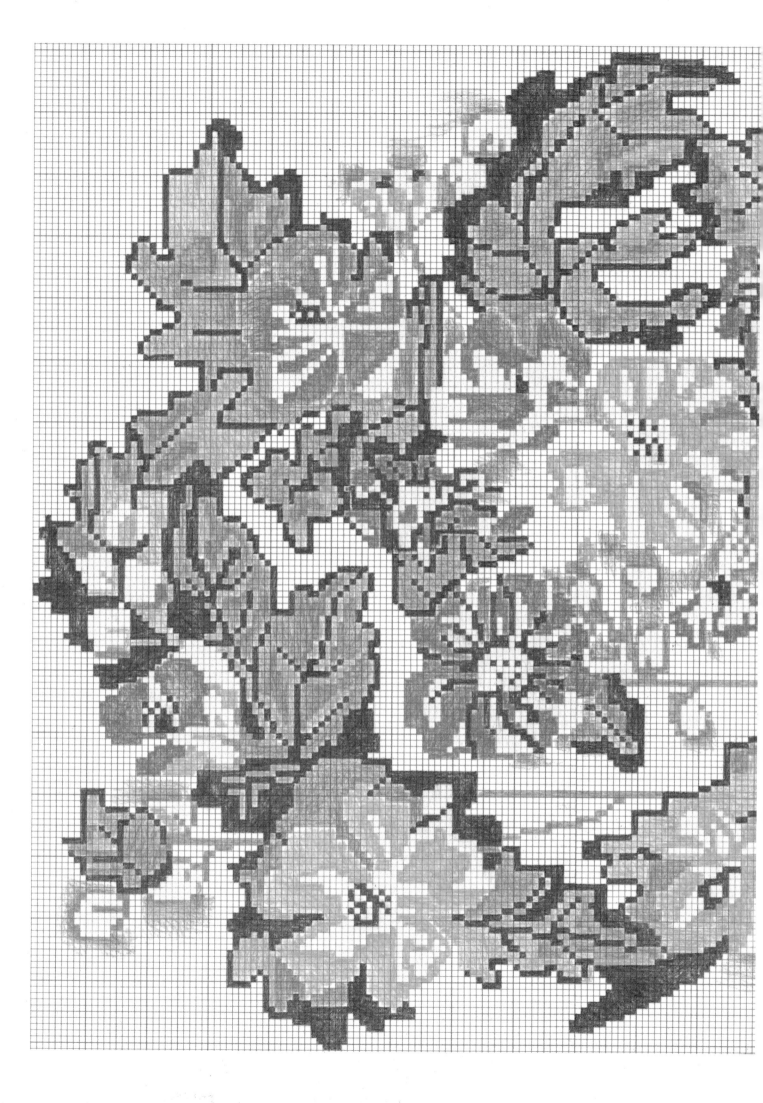

MATERIALS

1 piece of 13-mesh interlocked canvas,
 18 × 20in (46 × 51cm) or allow 4in
 (10cm) waste for the size of your
 chair seat
Blunt-ended needle
Paper for pattern cutting
Waterproof pen
Paterna Persian tapestry wool – use
 two strands throughout

- 2 skeins cream (948)
- 2 skeins light green (665)
- 5 skeins mid-green (663)
- 4 skeins dark green (662)
- 2 skeins light pink (964)
- 2 skeins mid-pink (906)
- 1 skein dark pink (903)
- 17 skeins grey (203)

METHOD

Use pattern-cutting paper to cut out
the shape of your chair seat, and draw
round your paper pattern on to the
canvas. Begin to work the floral design
in the centre of your canvas, working
in tent stitch throughout. When the
design is complete, work the
background in grey. Block the canvas
(see Techniques, page 104), then trim,
leaving enough waste to fit under your
chair seat without fear of fraying.
Attach to the chair seat with
upholstery pins, stretching the canvas
carefully.

MORNING GLORY POUCH

A pretty pouch which could be used as a nightdress case, handbag or overnight bag.

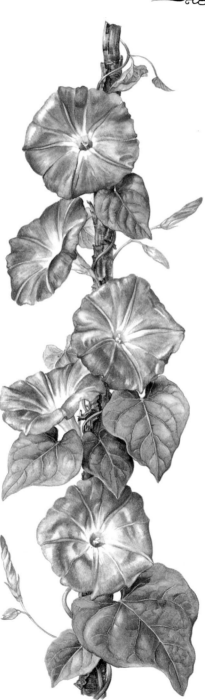

In the early 1600s John Goodyer of England described the flowers of the morning glory, *Ipomoea purpurea*, as 'Those that will open in the morning, making some small shewe overnight'. The Reverend William Hanbury, writing in the eighteenth century in *A Complete Book of Planting and Gardening*, compared the flower with the life of man: 'It has flower buds in the morning, which will be full blown by noon, and withered up before night.'

The glorious variety of colours, including the delicate pale blue and white flowers, were a great inspiration to the Dutch and Flemish flower painters, and in the twentieth century the American painter Audrey Buller produced an oil painting depicting the flowers that hangs in the Metropolitan Museum of Art in New York.

The root of the plant was once used to produce a harsh purgative medicine called scammony, which was used with great caution by the Greeks. During the 'hippy' era of the 1960s it was suggested that the seeds of morning glory contained a narcotic property that could cause hallucinations. This was later disproved, and the plant was declared harmless.

Morning glory is in the same family as bindweed, and it, too, is a superb climber and will grow up walls and fences in warm and sheltered positions. It flowers between June and September. In the language of flowers, it means departure or farewell.

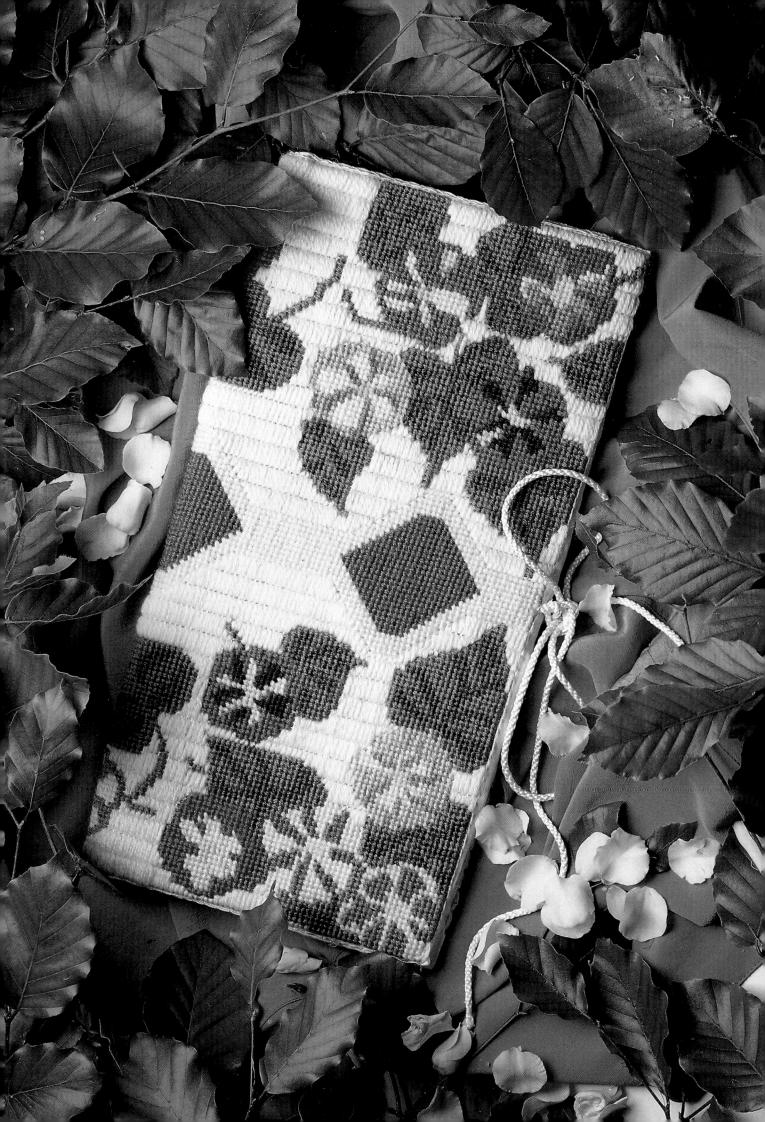

MATERIALS

1 piece of 10-mesh interlocked canvas,
 20 × 19in (51 × 48cm)
20in (50cm) cotton backing fabric
Strong sewing thread
Blunt- and sharp-ended needles
Waterproof pen
20in (51cm) satin cord
Paterna Persian tapestry wool – use
 three strands throughout

1 skein plum (320)
2 skeins mauve (332)
1 skein fuchsia (353)
2 skeins pink (354)
1 skein rose (903)
1 skein yellow (761)
1 skein pale pink (964)
4 skeins green (662)
4 skeins green (621)
2 skeins blue (342)
13 skeins cream (263)
2 skeins ecru (261)

METHOD

Use a waterproof pen to mark the position of the chart in
the centre of your canvas. Work the flowers, diamond
motif and central band in tent stitch, and work the
background in horizontal long stitch over five holes of the
canvas – i.e., you should have three free holes under each
stitch. When the design is complete, block your canvas (see
Techniques, pages 104) and trim; turn under the edges and
press lightly. Cut a pice of lining fabric to fit the canvas,
allowing a turn-in of ¾in (2cm) all round. Turn in the
edges and stitch neatly to the canvas. Cut a second piece of
lining fabric 6in (15cm) wider but 1½in (4cm) shorter than
the canvas. Oversew the two sides edges to the existing
lining, leaving 1in (2.5cm) at the top. Make a pleat at each
bottom side edge to take in the extra fabric and form a
gusset. Oversew the bottom edge to the existing lining and
secure the pleats. Sew a length of satin cord to the centre
of the top and bottom edges, fold the canvas in half
horizontally and tie the cords in a bow.

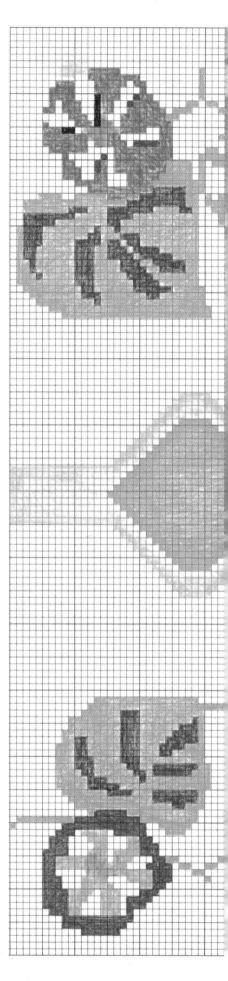

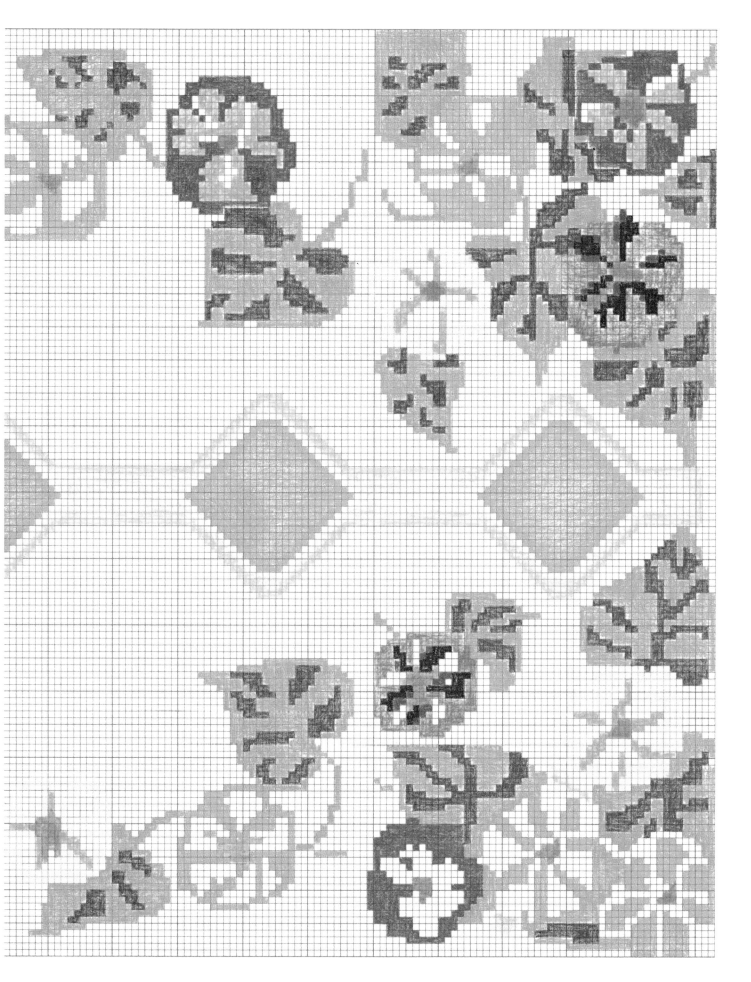

NASTURTIUM THREAD HOLDER

This case for tapestry yarns is made by working the complete chart once and then by reversing the image. The background is worked in tent stitch and the flowers are worked in satin stitch. Take care to work the satin stitch in the direction shown on the chart. The completed design with its mirrored images would also make a wonderful art deco-style cushion, especially if you used black satin for a border, backing and frill; work on the same principles as described in the instructions for the sweet pea cushion (see page 88).

The brilliantly coloured, exotic-looking flowers of the nasturtium, *Tropaeolum majus*, range in shade from a delicate apricot to vivid red. The generic name is derived from the Greek *tropaion* (trophy), the pillar set in a battlefield on which captured armour was hung.

In 1702 Linnaeus' daughter reported seeing sparks of light fly out of the nasturtium around sunset on summer evenings. Goethe also wrote of seeing these same flashes of light, and this started a craze of 'nasturtium watching', although modern science now describes the phenomenon as merely an optical illusion.

The round leaf was thought to suggest a shield, and the flower a spear-pierced, blood-stained, golden helmet. The name nasturtium is derived from Latin *nasus tortus* (distorted nose) because of the plant's pungent smell; the flower shape itself is similar to that of a nose.

The nasturtium was introduced to Britain from its native Peru, via Spain, in 1597. Herbalists believed the plant would 'purge the brain and quicken the spirit'.

For centuries nasturtiums were grown in kitchen gardens and used in salads. The leaves and flowers can also be made into a rich soup and even a sandwich filling. The seeds can be pickled and used as a substitute for capers, or dried and powdered for use as a mustard.

To pickle the seeds, pick them when they are still green, immediately after the flowers have dropped, and soak them in brine for 24 hours (make the brine from 100g (4oz) salt to 900ml (1½pt) water). Dry the seeds thoroughly and pack them into small jars. Make a spiced vinegar by boiling together white wine, vinegar, salt, tarragon leaves and garlic, add peppercorns and pour the hot solution over the seeds. Seal and leave for one month before eating. Once open, use up the contents quickly.

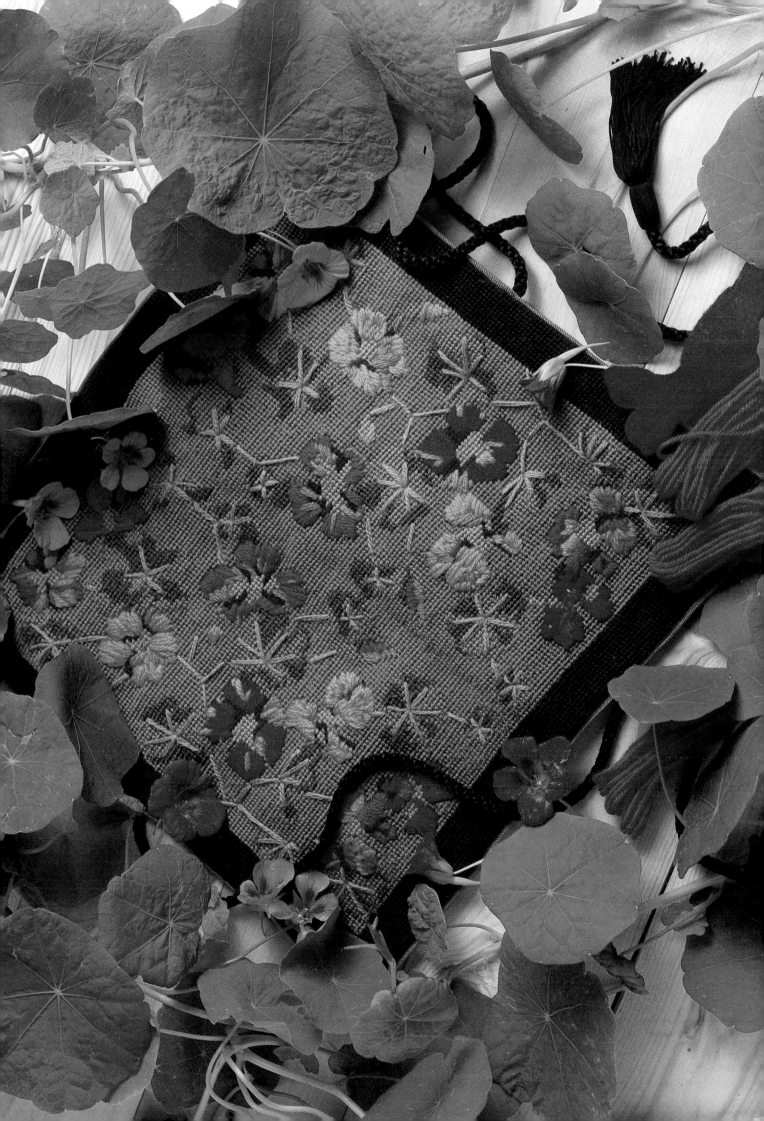

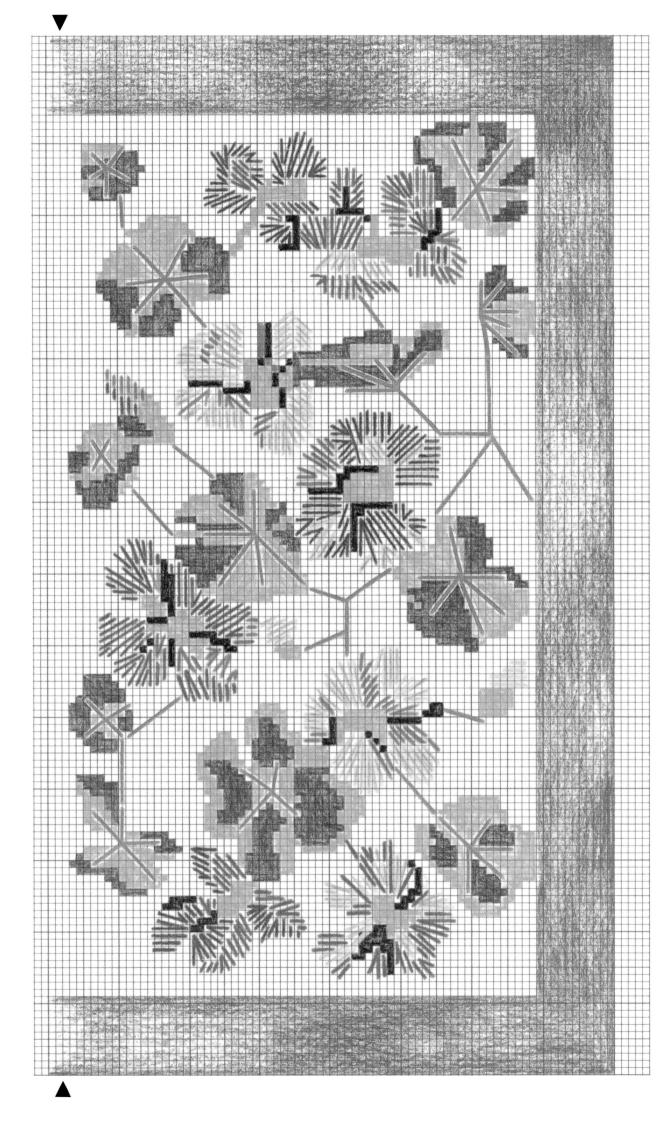

MATERIALS

1 piece of 10-mesh interlocked canvas,
 20 × 20in (50 × 50cm)
Black chintz cotton or a backing
 material of your choice
1½yd (1.5m) black elastic, ¾in (2cm)
 wide
Strong black sewing thread
Blunt- and sharp-ended needles
Black tassled cord (available at most
 stores stocking furnishing fabrics)
2yd (2m) coloured piping
Paterna Persian tapestry wool – use
 three strands throughout

14 skeins turquoise (591)
9 skeins charcoal (221)
2 skeins brown (400)
2 skeins flame (820)
1 skein orange (811)
2 skeins light orange (802)
2 skeins gold (771)
3 skeins dark green (691)
2 skeins mid-green (692)
2 skeins light green (693)

METHOD

Centre the design on the canvas,
bearing in mind that you will be
working a mirror image. Work the
flowers in satin stitch, the background
in tent stitch and the stalks and leaf
veins in long stitch. When the chart is
complete, work it again, but as a
mirror image. Block the finished canvas
(see Techniques, page 104), trim it and
fold in the waste. Cut the backing
fabric to fit, with a seam allowance of
about 1¼in (3cm), fold in the edges
and stitch it neatly to the wrong side
of the canvas, inserting the coloured
piping all round. Sew two strips of
elastic to each half of the lining,
allowing space for two rows of
tapestry threads. Make 15 loops with
each piece of elastic by holding it over
a skein of tapestry yarn so that it fits
snugly, then sewing it down. Take
care not to sew across the stitches on
the right side but to catch the cotton
down between stitches so that the
lining does not bag with the weight of
the yarns when they are inserted under
the loops.

Find the centre of the tassled cord
and attach it to the centre edge of the
completed canvas. Fold the needlepoint
in half and then in half again; then
fasten the cord around this in a bow to
secure the roll.

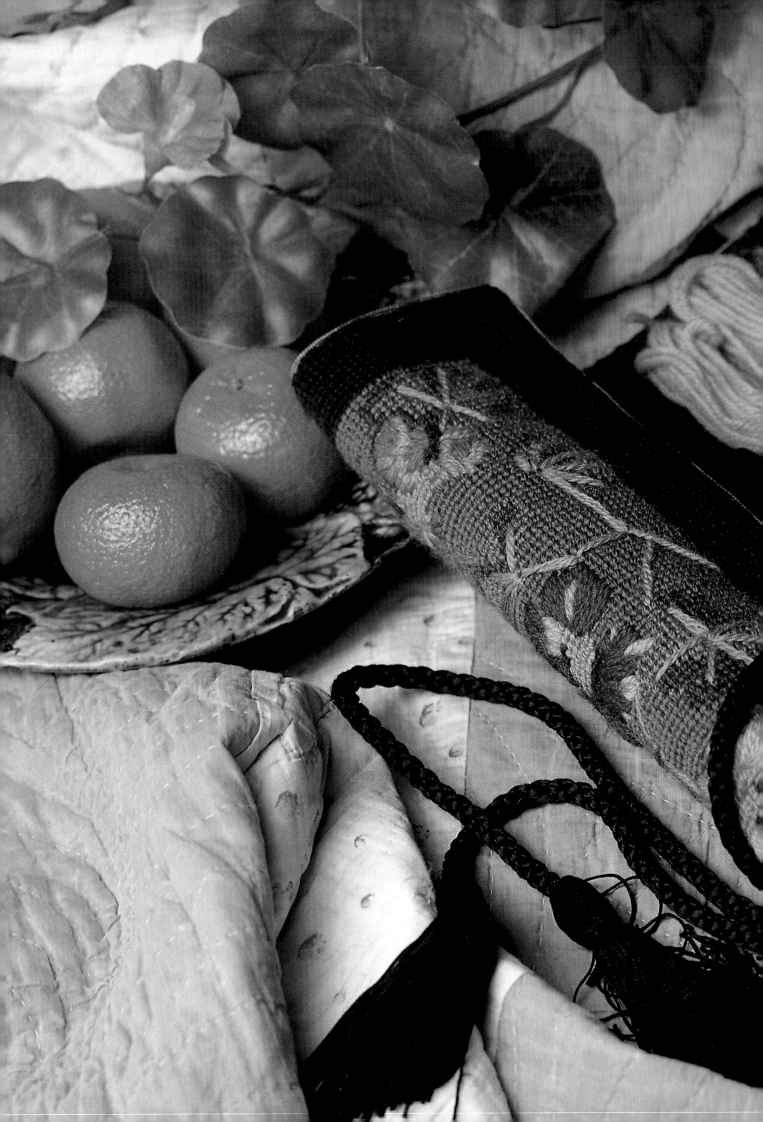

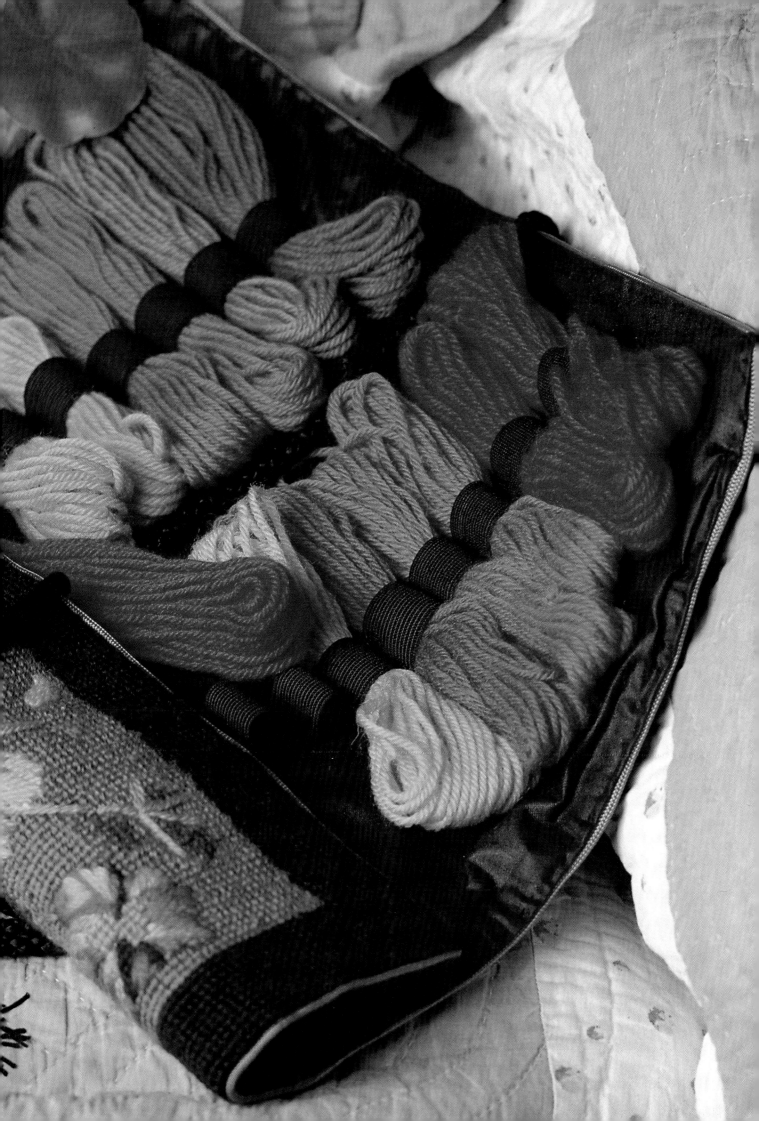

PANSY BELT

This pansy belt is simple to work and can be made to fit any size waist. The chart is worked twice and joined with random, vertical stripes at the centre back, the number of which can be increased or decreased according to the required size.

In the language of flowers pansy, *Viola tricolor*, means thoughts, and one explanation of the name is that it originated from the French word *pensée* (thought). An alternative explanation was offered by Dr Johnson, the lexicographer, who suggested that the name was derived from the word *panacea*, because the pansy was supposed to be a cure for French pox, an old name for venereal disease.

The cultivated pansy that we see in gardens today did not exist until the mid-nineteenth century, and these modern pansies were hybridized from the wild pansy, which was otherwise known as heart's ease and was described by Shakespeare as love-in-idleness. In *A Midsummer Night's Dream* it was this flower, used as a love potion, that caused Titania to fall in love with an ass.

The pansy, with its smiling face, is a favourite among country folk and is known affectionately as two-faces-under-the-sun, face-and-hood and tickle-my-fancy. It has also been called herb Trinity since there are sometimes three colours in one flower, which is symbolic of the Holy Trinity. In all, over two hundred different names are attributed to this flower throughout Europe, and at least sixty in English.

The pansy was a favourite of Elizabeth I, and the Empress Josephine, wife of Napoleon Bonaparte, also cultivated the flowers in her gardens at Malmaison. In Victorian times the flowers were extensively hybridized to produce magnificent markings and symmetrical forms and were widely grown for exhibition purposes.

An old German legend suggests that the pansy once had as fine a perfume as the violet, but, as it grew wild in the fields, the people sought it with such enthusiasm that they heedlessly trampled the grass needed for cattle and the vegetables required for their own tables. Seeing the wreck that was wrought by this eagerness, the flower prayed to the Trinity to take away its perfume that it might be no longer sought.

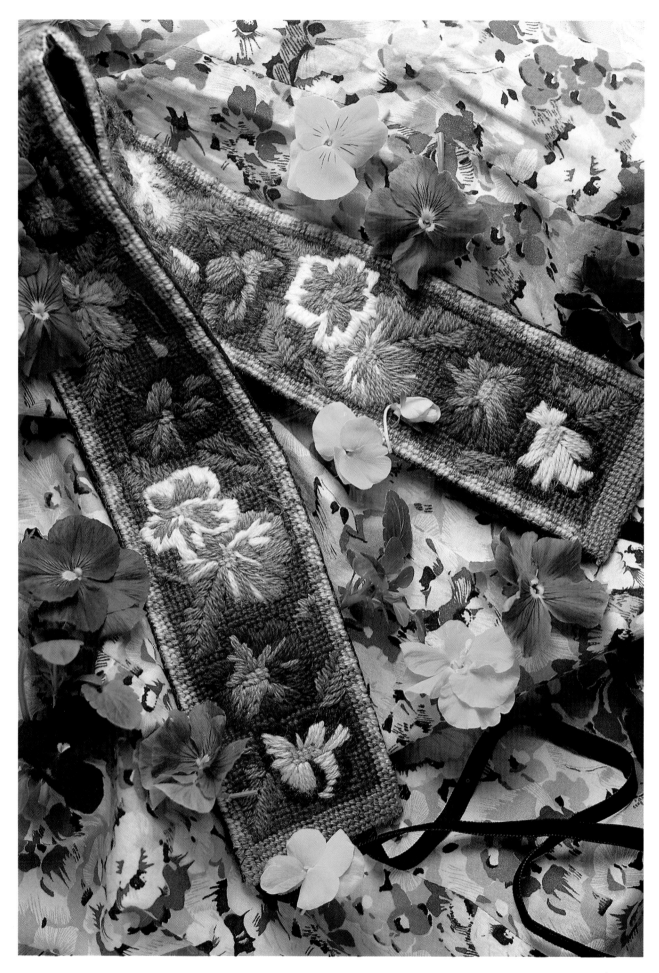

68 · BELT

MATERIALS

1 piece of 10-mesh interlocked fabric,
6in (15cm) deep and 4in (10cm)
longer than the required length of
the finished belt

Backing fabric, 4in (10cm) deep and
1in (2.5cm) longer than the length of
the finished belt

Sewing thread

Blunt- and sharp-ended needles

2yd (2m) velvet or satin ribbon, ¾in
(1.5cm) wide

Paterna Persian tapestry wool – use
three strands throughout

2 skeins plum (320)
1 skein mauve (332)
1 skein rose (322)
3 skeins blue (342)
2 skeins purple (330)
3 skeins green (631)
3 skeins yellow (727)
1 skein butter (771)
4 skeins rust (861)
2 skeins white (261)

METHOD

Leaving an allowance of 2in (5cm) at
each end of the canvas, cut a strip that
will fit neatly around your waist. Start-
ing 2in (5cm) in from the edge of the
canvas, begin working from the chart
using satin stitch for the flowers
(noting the direction of the arrows on
the chart) and tent stitch for the back-
ground. Then repeat the chart at the
other end of the canvas and fill in the
area in between with random coloured,
vertical stripes. Fold under the short
ends of canvas and then the long ends
and tack them into place. Sew the
backing material neatly to the canvas,
turning under the edges. Stitch the
ribbons into position (see photograph)
and tie them together in bows.

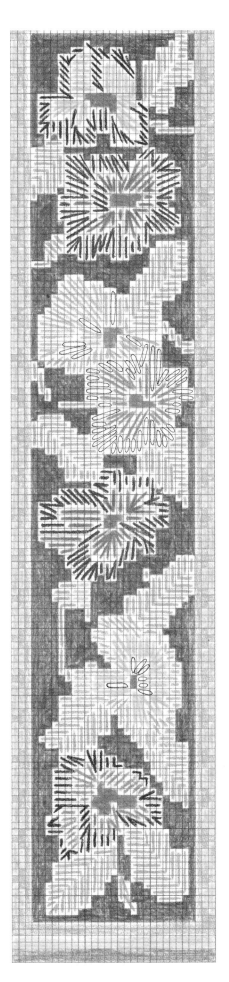

POPPY FIRESCREEN

This elegant firescreen is produced on fine-mesh canvas in stranded cotton and is worked entirely in tent stitch. Obviously the size of a basic screen you use may vary from the one shown here, and you can alter the size of the needlepoint by changing the mesh of the canvas or by working a plain border around the design so that it fits. The design would also make a lovely cushion or, worked on a much larger mesh, a rug. The finished size of the design we worked is 24in (61cm) high and 18½in (46.5cm) wide.

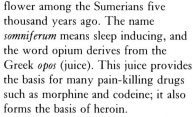

Between June and September the common red poppy, *Papaver rhoeas*, dances in the cornfields of England and Ireland. There are many legends as to its origins, and in England some say that the poppy appeared from the blood of the dragon slain by the holy maid Margaret.

The plant contains a milky juice of a narcotic nature, and the opium poppy, *Papaver somniferum*, was a cult flower among the Sumerians five thousand years ago. The name *somniferum* means sleep inducing, and the word opium derives from the Greek *opos* (juice). This juice provides the basis for many pain-killing drugs such as morphine and codeine; it also forms the basis of heroin.

It is said that after the battle of Neerwinden in World War I the fields were covered with scarlet poppies, which the people looked upon as the spilled blood of twenty thousand soldiers and as a sign of heaven's anger at the evil deeds of men. In the East too, where the flower is known as little dawn, the plains and vales over which battles raged are still splashed with these flowers, 'blooming in barbaric splendor, gloating on the gore of soldiers slain'.

When Custer was massacred by the Sioux Indians, poppies appeared on the battlefield, where they were called Custer's heart. It was suggested that these flowers had sprung from the blood of the slain fighters on that day in 1876.

Poppy seeds are widely used in cakes and confectionery, and an oil extracted from the seeds is considered to be second only to olive oil. Seed heads are ready for picking in September when they become greyish-brown, and the seeds are delicious sprinkled on bread or mixed to a paste with sugar to use as a cake filling.

Red ink can be produced from poppy flowers by steeping one cup of petals overnight in boiling water. Add 15 per cent vodka to preserve the solution, strain and bottle.

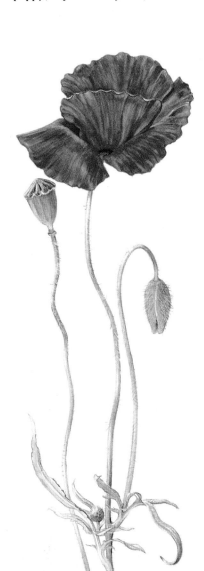

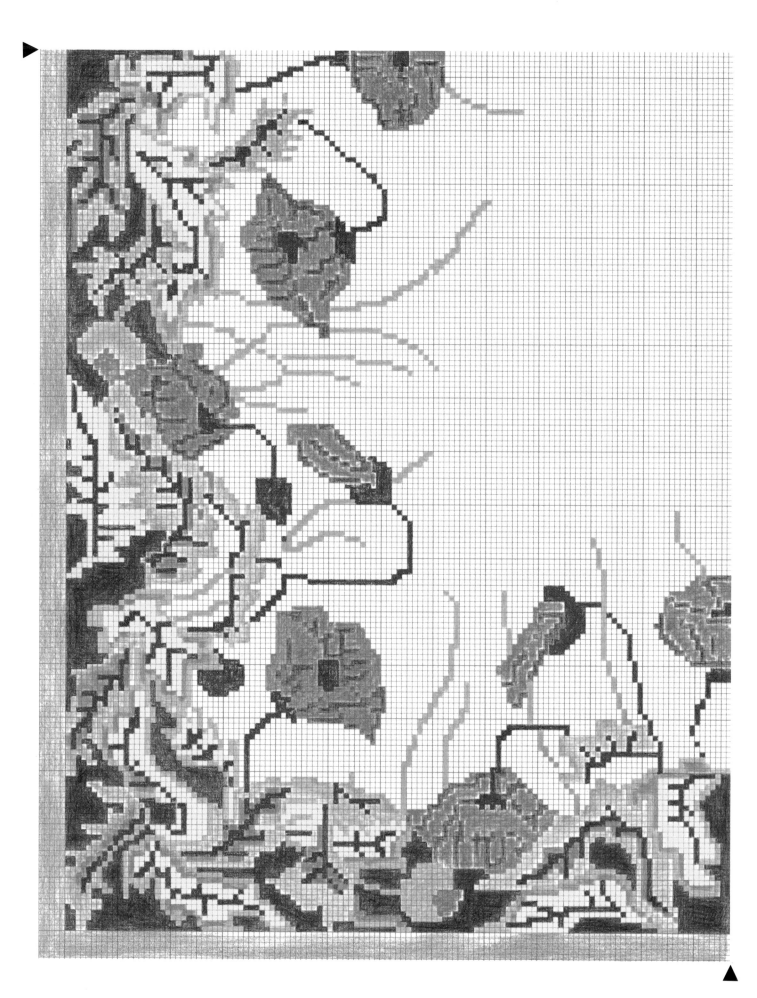

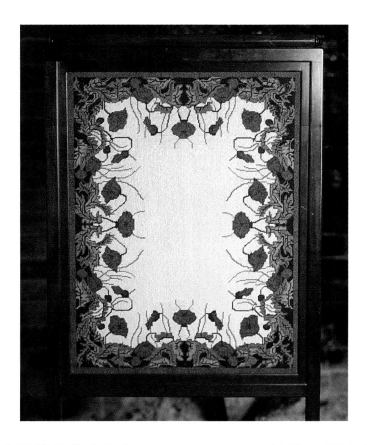

MATERIALS

1 piece of 14-mesh interlocked canvas,
 26 × 26in (66 × 66cm)
Furnishing fabric to fit back of screen
Blunt-ended needle
Waterproof pen
Upholstery pins or staple gun
Rubber-based adhesive
Anchor stranded cotton – use six
 strands throughout

- 40 skeins ivory (0852)
- 8 skeins navy blue (0152)
- 5 skeins dark olive (0906)
- 7 skeins green (0269)
- 6 skeins gold (0888)
- 4 skeins olive (0856)
- 3 skeins coral (0884)
- 6 skeins red (013)
- 3 skeins wine (022)
- 10 skeins khaki (0861)
- 9 skeins dark brown (0382)

METHOD

Mark the position for your chart in the centre of your canvas and, following the chart, work the first corner of the design, using tent stitch throughout. Use a mirror image of the chart for the second corner, and repeat the process for the third and fourth corners. Fill in the centre area in ivory, making sure that you work with clean hands! Carefully block the finished canvas (see Techniques, page 104), and secure to the firescreen frame using upholstery pins or a staple gun. Back the panel with a furnishing fabric of your choice either by stitching it to the edges of the canvas or by glueing it carefully into position with a rubber-based adhesive. Alternatively, your local picture framing shop will be able to mount your canvas on to your screen for you.

ROSE RUG

A glorious floor rug, thick with full-blown roses of every conceivable colour, may be a tempting thought, but the idea of muddy feet trampling across weeks of painstaking work could be a little off-putting. Our completed rug was produced from two repeats of the chart, and it could be made larger simply by repeating the design horizontally or vertically as many times as you wish and adding the border when you have finished. If you want to keep to two repeats, you could use the rug on a table, Dutch style, or omit the top fringe and use it as a wall hanging, which would, at least, protect it from those muddy feet.

Some authorities suggest that the generic name *Rosa* and our own word rose are derived from the Celtic *rhos*; others say that they come from the Greek *rodon*. Both words mean red, and the rose of the Ancients was a deep red colour, which may account for the fable that it sprang from the blood of Adonis.

One Greek legend has it that the rose was said to be a beautiful lady from Corinth named Rhodanthe. She was constantly besieged by kings and lords, eager to win her love, and to escape her admirers she fled to the temple of the goddess of purity, Artemis. Unfortunately, her suitors and the townsfolk followed and stormed the temple gates. Artemis, angered at the outrage, changed Rhodanthe into a red rose – the colour represented the blush that spread over her lovely face when she was exposed to the gaze of her admirers.

Another Greek legend suggests that the rose was created by Chloris, the goddess of flowers, from the lifeless body of a nymph she found one day in a clearing in the woods. Chloris asked for help from Aphrodite, the goddess of love, who gave beauty, from Dionysus, the god of wine, who added nectar to give a sweet scent, and from the three Graces, who gave charm, brightness and joy. Then Zephyr, the west wind, blew away the clouds so that Apollo, the sun-god, could shine and make the flower bloom. On blooming, the flower was crowned queen of all flowers.

In the West the rose has often been used as an emblem, and it is today regarded as the national flower of England.

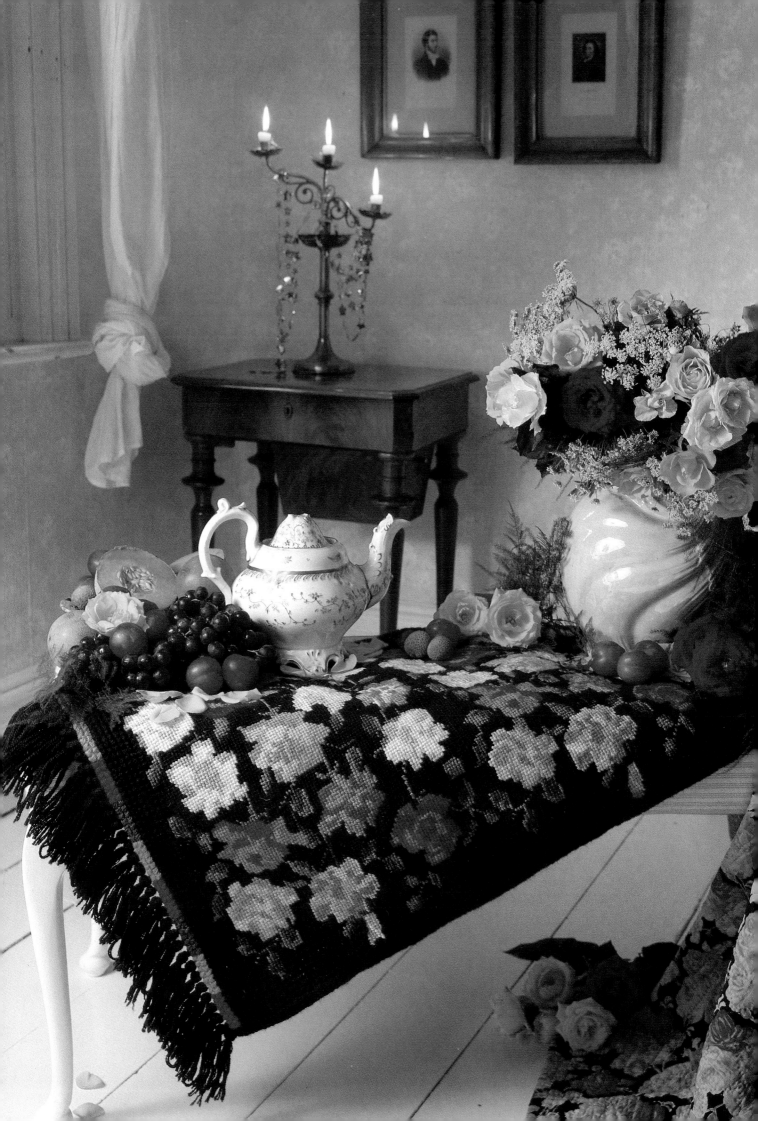

MATERIALS

1 piece of 7-mesh interlocked canvas,
35 × 28in (89 × 71cm)
Large-eyed blunt-ended needle
Paterna Persian tapestry wool – use six
strands throughout

- 3 skeins red (940)
- 5 skeins red (942)
- 1 skein coral (953)
- 4 skeins red (944)
- 6 skeins coral (934)
- 3 skeins coral (933)
- 1 skein rose (943)
- 4 skeins yellow (725)
- 2 skeins yellow (726)
- 1 skein yellow (727)
- 3 skeins yellow (704)
- 8 skeins ecru (261)
- 11 skeins green (692)
- 11 skeins green (691)
- 2 skeins pink (964)
- 2 skeins rose (903)
- 2 skeins rose (905)
- 1 skein rose (904)
- 3 skeins lavender (334)
- 4 4oz (113g) hanks dark plum (320)
- 1 skein pink (925)

METHOD

Position the design at the centre of
your canvas, bearing in mind that you
will be working two repeats, and begin
to work the inner section of chart,
using six strands of yarn and working
in tent stitch throughout. When this is
complete, repeat the chart once more
from row 1. Then work the border
area in large cross stitches, which
should be worked over three strands
both horizontally and vertically (you

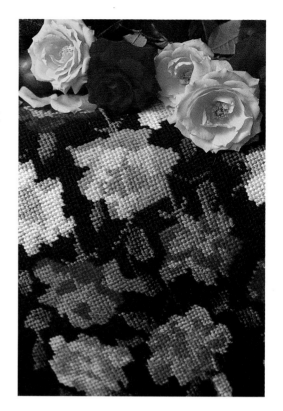

should have one free hole in the centre
of each stitch). Add the striped border
at the top and bottom.

Block the canvas if necessary (see
Techniques, page 104), then trim any
waste so that you have eight holes free
at the top, bottom and sides. Fold this
waste canvas in half so you have a
double edge showing, four holes deep.
Oversew this edge with base colour to
form a plain border. Cut lengths of
base colour yarn measuring
approximately 10in (25cm), and thread
four strands halfway through the top
edge of your work at the centre of the
first cross. You will now have eight
free strands. Knot these together, and
repeat the process every three stitches,
at both ends of the canvas. Trim the
ends neatly.

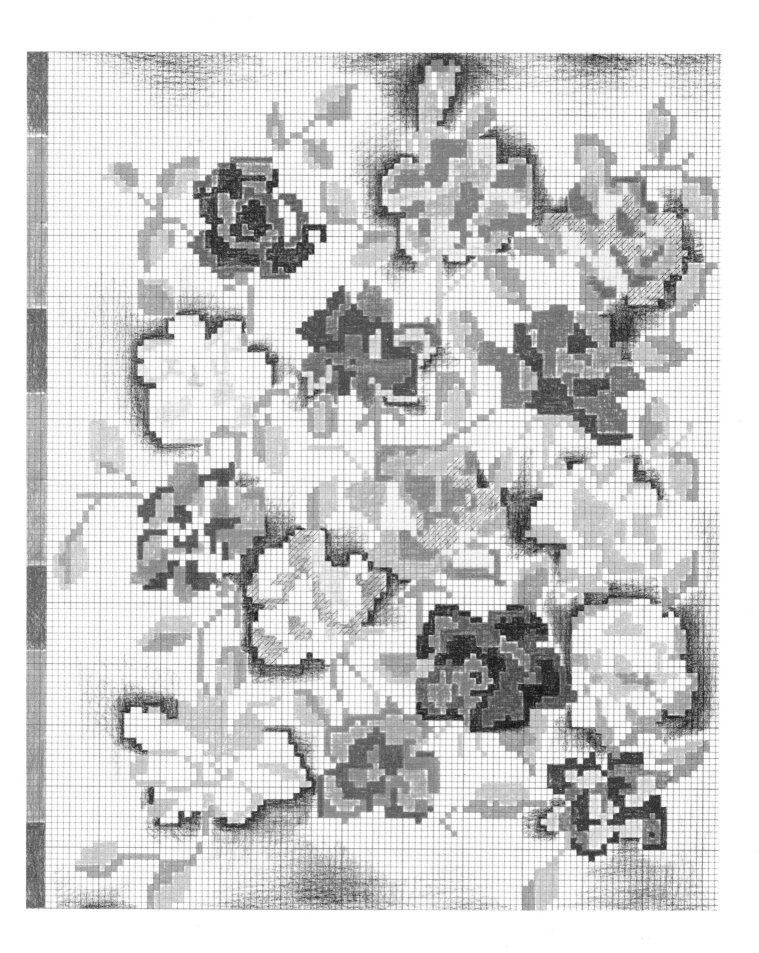

PRIMROSE CUSHION

This circular cushion is worked with a green velvet surround and, when finished, will measure approximately 21in (53cm) in diameter. The finished canvas is approximately 13in (33cm) in diameter. Both these dimensions may be adjusted by working the design on a smaller mesh of canvas or by cutting a narrower border for the surround. Alternatively, if you do not want to or feel you cannot make up the cushion, you can simply stitch your finished canvas to the centre of an existing cushion.

The primrose, *Primula vulgaris*, is traditionally the first flower to appear in spring, and it is therefore a particularly welcome sight in woodlands and on hedgerow banks where it flowers during April and May. The name may be derived from a twisting of the Italian words *fiore de prima vera* (first flower of spring), or from the French word *primerole*. In some parts of western England it is still referred to as the butter rose because the colour of the petals resembles the butter that is made there.

Primroses tend to have morbid associations since, in the past, the flowers were used to dress corpses and were scattered on graves. They were also known to be Disraeli's favourite flower, and on his death Queen Victoria sent a wreath of primroses from Osborne House as a token of her affection and respect.

The flower also has deeply sentimental associations since it was once a human creature: Paralisos, son of Flora and Priapus, died of heartbreak for the loss of his sweetheart and was changed by the gods into this rustic and cheerful blossom.

Primrose leaves are delicious in salads or boiled as a pot-herb. The petals can also be crystallized and used as cake decorations.

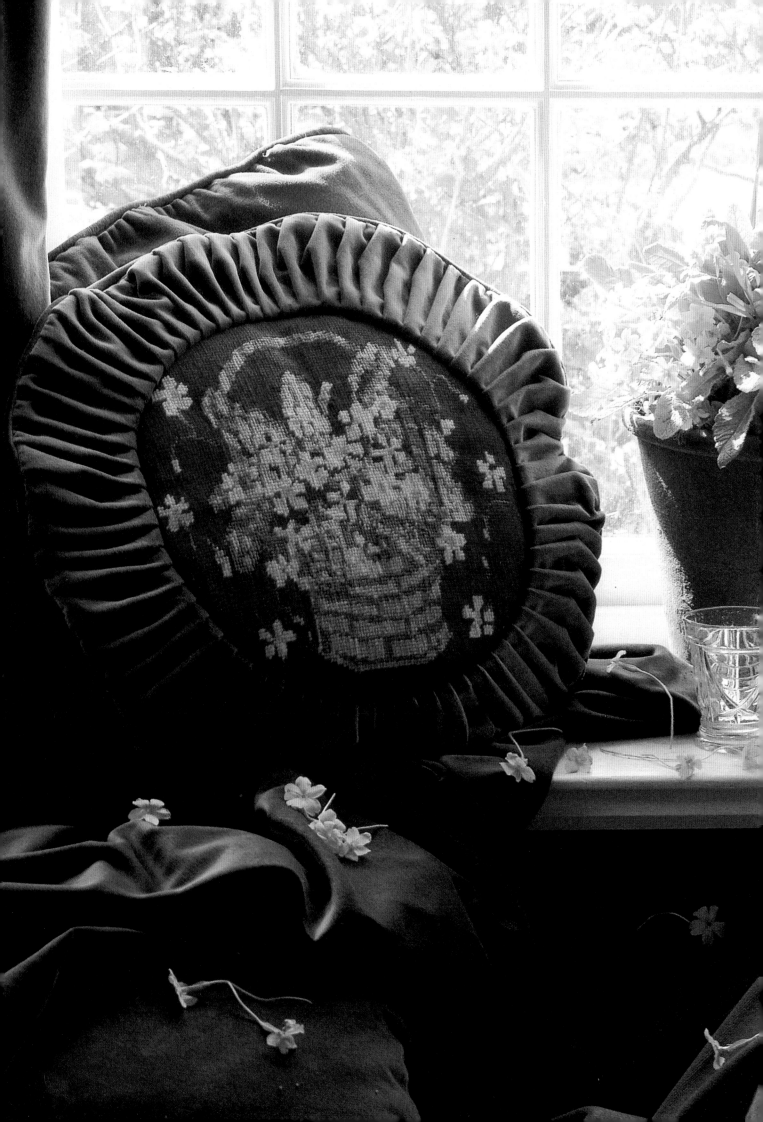

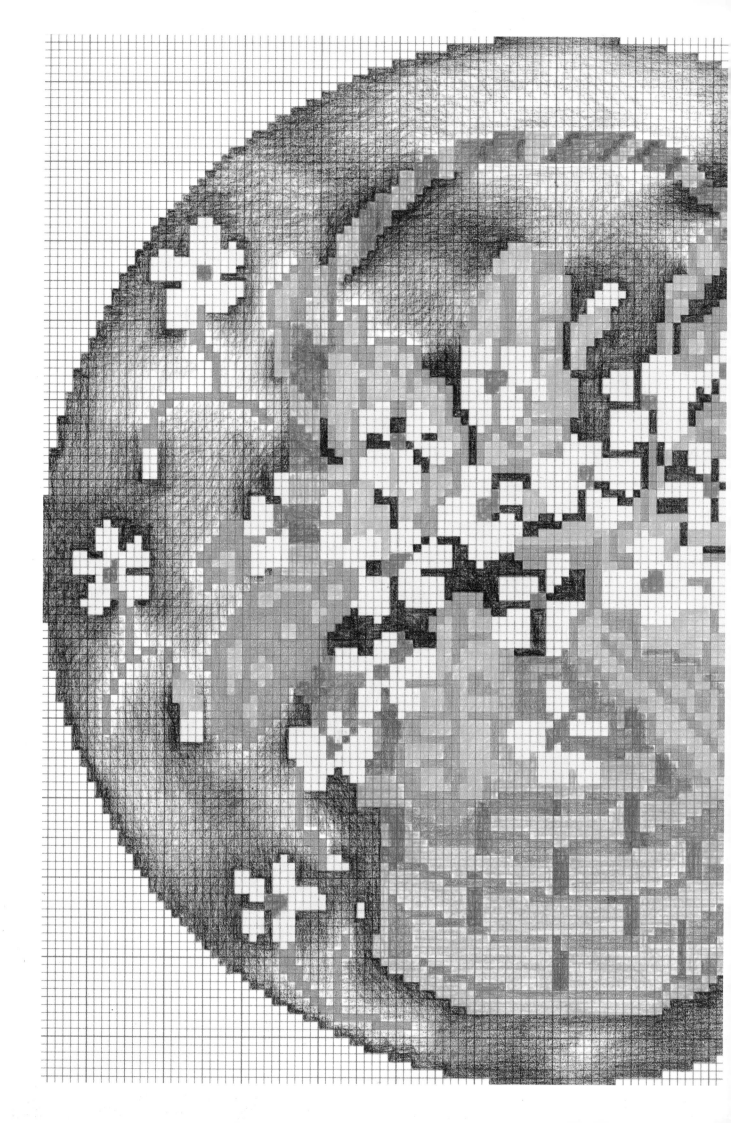

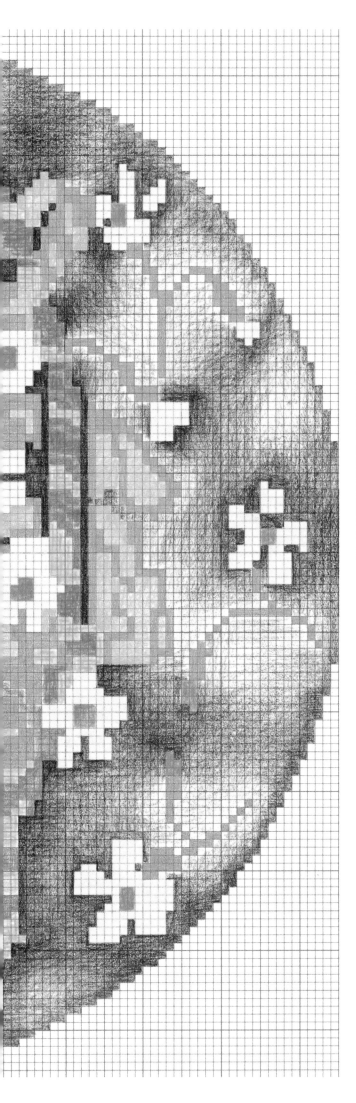

MATERIALS

1 piece of 10-mesh interlocked canvas,
 18 × 18in (46 × 46cm)
1 piece of green velvet to match,
 40 × 40in (1 × 1m)
Cushion pad, 21in (53cm) in diameter
2yd (2m) piping cord and covering
Strong green sewing thread
Blunt- and sharp-ended needles
Paper for pattern cutting
Waterproof pen
Paterna Persian tapestry wool – use
 three strands throughout

<table>
<tr><td>1 skein orange (770)</td></tr>
<tr><td>2 skeins yellow (761)</td></tr>
<tr><td>1 skein dark tan (731)</td></tr>
<tr><td>2 skeins camel (734)</td></tr>
<tr><td>9 skeins dark brown (920)</td></tr>
<tr><td>1 skein grey (462)</td></tr>
<tr><td>1 skein dark green (631)</td></tr>
<tr><td>2 skeins light green (633)</td></tr>
</table>

Do not, as some ungracious pastors do,
Show me the steep and thorny way to heaven,
Whiles, like a puff'd and reckless libertine,
Himself the primrose path of dalliance treads,
And recks not his own rede.
 HAMLET, *WILLIAM SHAKESPEARE (1564–1616)*

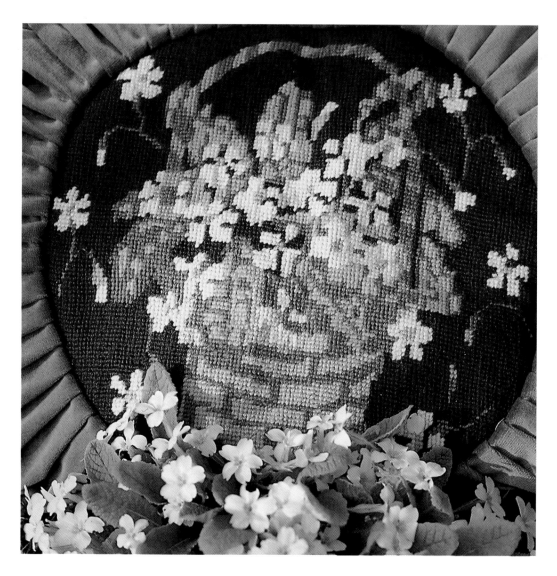

METHOD

Using a waterproof marking pen, draw a circle on your canvas, measuring 13in (33cm) in diameter and leaving 2½in (6cm) waste canvas all round the design. Work the whole design in tent stitch. When it is complete, block the canvas (see Techniques, page 104) and trim it, leaving a border of 1¼in (3cm). Fold this border to the back of your work and tack it down. Lay the canvas on a sheet of pattern-cutting paper and draw a circle 4¾in (12cm) wider than your canvas. Fold this piece in half and cut two semicircles from the green velvet leaving a 3½in (9cm) allowance at the straight edges. Fold back ½in (1cm) at the straight edges and hem neatly. Cut three strips from the remaining velvet, each measuring 1yd (1m) by 5in (13cm). Join the short ends to make a continuous strip 3yd (3m) long. Place a running thread approximately ¾in (1.5cm) in on one long edge and gather it into even pleats to fit around the tapestry. Tack the second edge to match. Stitch it in place neatly around the tapestry, and join the final short ends.

Cover the piping cord with fabric and stitch it around the pleated edge. Turn in the curved edges of the semi-circles and attach one to the bottom half of the cushion at the piped edge. Lay the second semicircle so that the straight edge overlaps the bottom half of the back and stitch it to the front at the piped edge, thus forming an envelope. Insert the cushion pad.

SUNFLOWER AND IRIS PICTURE

This is a very simple design, which was worked in half-cross stitch. If you prefer to use tent stitch allow an extra skein of each of the colours quoted. Worked on 10-mesh canvas, the picture measures 14½ × 19½in (37 × 50cm). You can, of course, adjust the size by altering the size of canvas mesh and frame it to your own taste.

SUNFLOWER

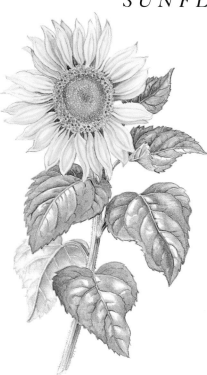

Various plants are known as sunflowers, including the chrysanthemum, marigold and the dandelion, but our coarse, honest and assertive sunflower, *Helianthus annus*, being such an obvious symbol of the globe of light, was much esteemed in Peru by the sun worshippers. Inca priestesses in the sun temples wore golden copies of these flowers, much to the delight of the Spanish conquerors, who immediately seized these shocking symbols of unauthorized religion and put the objectors to the sword.

The first sunflowers were brought to Europe from Central America in the sixteenth century. Though little was known about the properties of the plant, the Indians extracted the oil from the seeds and used the leaves as cattle feed. In Russia, where vast quantities are cultivated today, the flowers and leaves were used for the treatment of coughs, bronchitis and malaria. It has now been established that inulin, one of the constituents of sunflower oil, is very effective in the treatment of asthma.

The seeds, which are high in protein and calcium, are a delicious food, and a yellow dye can be made from the petals. Even the stalk can be processed to produce a silky fibre, which is excellent for writing paper.

In 1847 the Mormons used the seeds of the sunflower to mark their trail to Salt Lake City. They left Missouri looking for a place to worship, and they scattered sunflower seeds behind them when they crossed the Utah plains. This enabled the women and children, who would be travelling the following summer, to take the sunflower trails left by the men who preceded them.

Oscar Wilde brought the sunflower to the attention of the arts when he made the flower the symbol for the new aestheticism, and it was around this time that Van Gogh created his 13 famous paintings of sunflowers.

IRIS

The iris is one of the oldest cultivated plants in history. The plant is named after the rainbow goddess, Iris, because there are as many different shades of the flower as there are colours in the rainbow. In Greek mythology, Iris was the messenger of the gods, especially of Juno, and the rainbow was her bridge between heaven and earth. In Roman history the word *iris* means 'eye of heaven'.

It is believed that the iris plant was brought from Syria to Egypt almost fifteen centuries before Christ, and the Ancient Egyptians often used the flower to decorate the brow of the Sphinx.

In flower poetry the three leaves of the plant represented wisdom, faith and courage, but in the Middle Ages the juice from the rhizomes was used to cure 'spleens', coughs, bruises, fits, dropsy, snake bites and anger. The rhizomes were cultivated because they were believed to cure ulcers and induce sleep, and they were also suspended in barrels of wine or beer to help preserve the beverages.

The iris or fleur-de-lis is an important symbol in French history. Legend has it that Clovis, who was king of the Franks in the sixth century, was surrounded by a band of Goths near the river Rhine. Trapped, he looked across the river and saw some yellow irises growing way out into the water, which made him realize that the water was shallow enough to ford and provide a route for his escape. Clovis changed the three frogs on his banner for three irises, and the flower became the emblem of the French royal family. In 1147, Louis VII, on joining the crusades, chose the iris as his symbol in memory of Clovis. The flower then became known as *fleur de Louis*, and finally fleur-de-lis. At first the royal standards were thickly charged with the flowers, but in 1376 Charles V reduced the number to three to honour the Trinity.

In the language of flowers the iris represents eloquence, faith, promise and message. The plant flowers from May to late June and is found fringing rivers ditches and lakes.

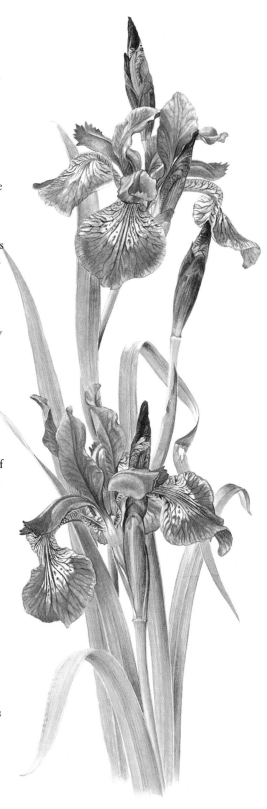

MATERIALS

1 piece of 10-mesh interlocked canvas,
 18½ × 24in (47 × 61cm)
Blunt-ended tapestry needle
Waterproof pen
Backing board
Paterna Persian tapestry wool – use
 three strands throughout

- 1 skein ecru (261)
- 3 skeins dark grey (200)
- 2 skeins light grey (203)
- 3 skeins leaf green (621)
- 3 skeins light green (623)
- 4 skeins dark blue (500)
- 2 skeins bright blue (541)
- 11 skeins blue (343)
- 1 skein mid-blue (542)
- 1 skein dark brown (920)
- 1 skein tan (424)
- 1 skein orange (801)
- 1 skein yellow (771)
- 1 skein dark mauve (300)
- 1 skein light mauve (302)

METHOD

Mark the position of the design on the centre of your canvas and, beginning at the bottom right-hand corner, follow the chart, working in half-cross stitch throughout, until it is complete. Block carefully (see Techniques, page 104), then mount the canvas on a board the size of your finished work. Frame according to your own preference.

Thou art the Iris, fair among the fairest,
Who, armed with golden rod
And winged with the celestial azure, bearest
The message of some God.

Thou art the Muse, who far from crowded
cities
Hauntest the sylvan streams,
Playing on pipes of reed the artless ditties
That come to us as dreams.

O Flower-de-Luce, bloom on, and let the river
Linger to kiss they feet!
O Flower of song, Bloom on and make forever
The world more fair and sweet.
HENRY WADSWORTH LONGFELLOW (1807–82)

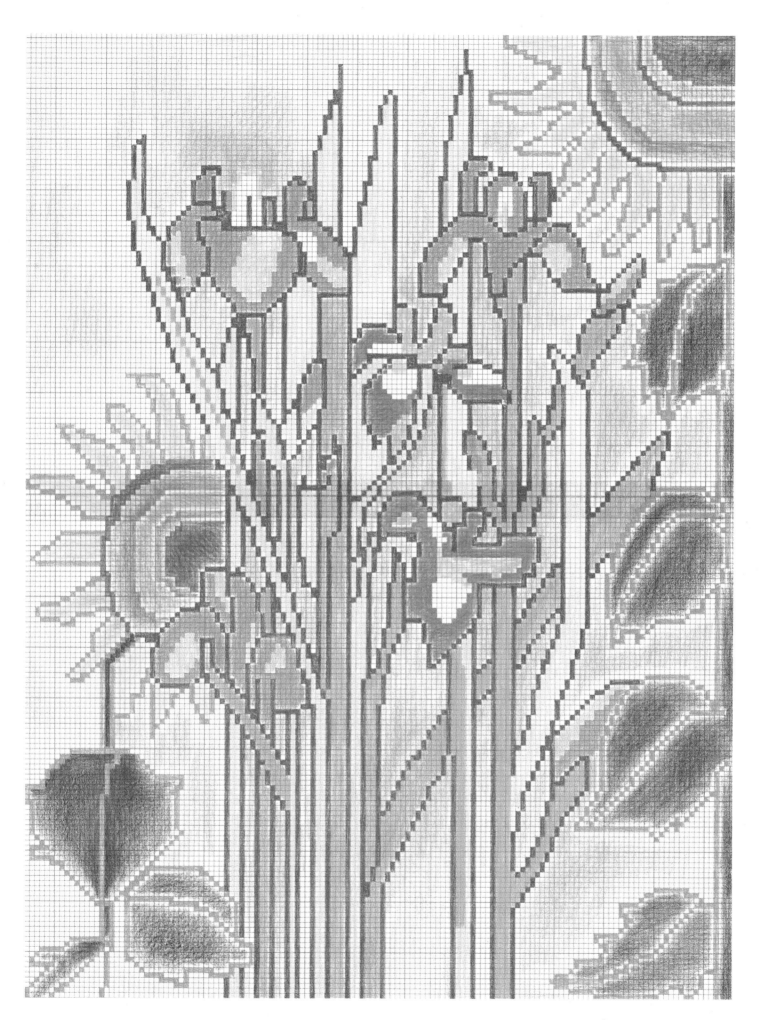

PICTURE · 87

SWEET PEA CUSHION

I felt the frilly flowers of the sweet pea deserved an equally frilly surround, so this simply worked design is backed and frilled with chintz, chosen to match the colours of the petals. For the less ambitious among us, you could, of course, mount the canvas on a simple cushion surround. The flowers are worked in satin stitch, and the background is worked in tent stitch. The border is quick-covering graduated diagonal stitch, and the stems are worked in straight stitch.

The sweet pea, *Lathyrus odoratus*, is a Sicilian wild flower, and the first written records of the plant were made by Father Cupani in *Hortus Catholicus*, which was published in 1697. It was introduced into England at the beginning of the eighteenth century.

The original flowers were rather straggly and limited in colour, but the plant's appearance improved when Silas Cole, gardener to Earl Spencer of Althorp Park in Northampton-shire, hybridized the first of the named cultivars.

In the language of flowers sweet pea means remember me, and it is a symbol of delicacy and departure.

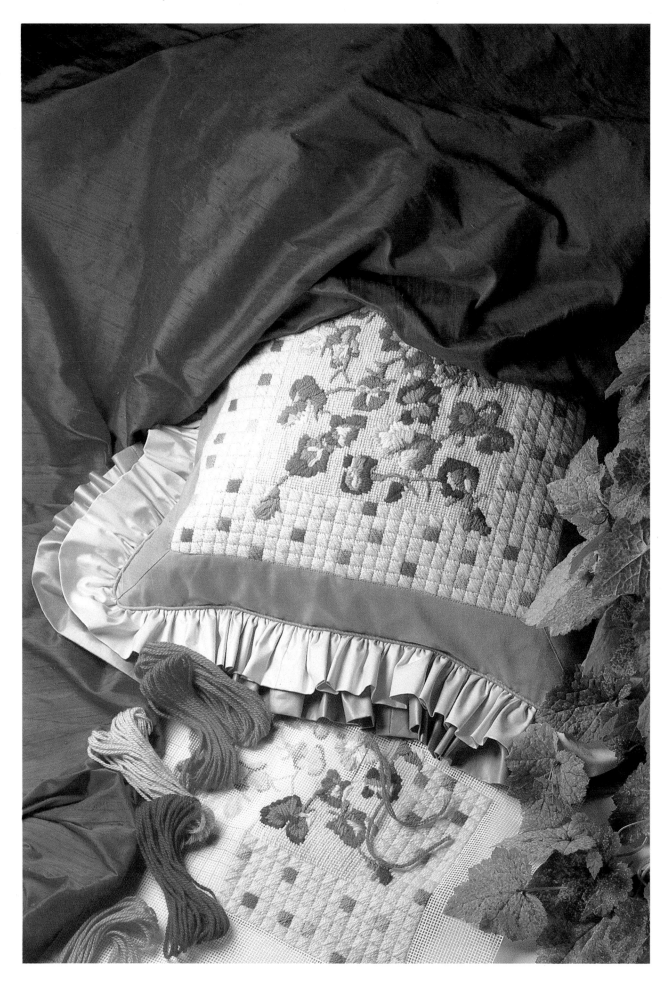

MATERIALS

1 piece of 10-mesh interlocked canvas,
 18 × 18in (46 × 46cm)
1½yd (1.5m) cream chintz
1yd (1m) purple chintz
10in (25cm) coral chintz
2yd (2m) piping cord
Cushion pad, 21in (54cm) in diameter
Strong sewing thread
Blunt- and sharp-ended needles
Waterproof pen
Zip fastener, 16in (41cm) long
Paterna Persian tapestry wool – use
 three strands throughout
 16 skeins cream (948)
 2 skeins green (693)
 2 skeins light blue (332)
 2 skeins lilac (334)
 2 skeins rose (953)
 1 skein pink (945)
 1 skein coral (955)
 1 skein dark rose (931)
 1 skein lime green (695)
 1 skein white (260)
 1 skein violet (300)
 1 skein mauve (302)

the piping cord with coral fabric and sew it around the outside edge of the purple fabric.

Cut two strips of cream chintz, each measuring 1yd (1m) by 7in (18cm) and join one set of short ends. Cut two strips of purple, each measuring 1yd (1m) by 8in (20cm) and join one set of short ends. Fold both these strips in

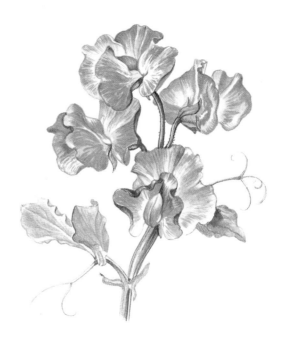

METHOD

Mark guidelines for the position of the chart, centring it on the canvas. Work the flowerheads and leaves in satin stitch. Use long straight stitches for the stems. Fill in the background of the flower panel in tent stitch, and work the border squares in diagonal stitch. Block the canvas (see Techniques, page 104) and trim it to within ¾in (2cm) of finished work. Turn back the waste canvas and press lightly.

Cut four strips of purple fabric, each measuring 24 × 5in (61 ×13cm). (These measurements include a 1in (2.5cm) seam allowance at every edge throughout.) Sew these strips neatly to the edges of the canvas and mitre the corners. The frame should now be approximately 3in (7.5cm) deep. Cover

half lengthwise, and tack the cream length on top of the purple length so that the cut edges are flush. Gather the strips 1in (2.5cm) from the cut edge and sew around the cushion, behind the piping. Join the remaining short ends. Cut two oblong pieces of cream chintz to fit the back without frills, and insert a 16in (41cm) zip fastener at the back. Join the centre seams on either side of zip and join the back to the cushion front.

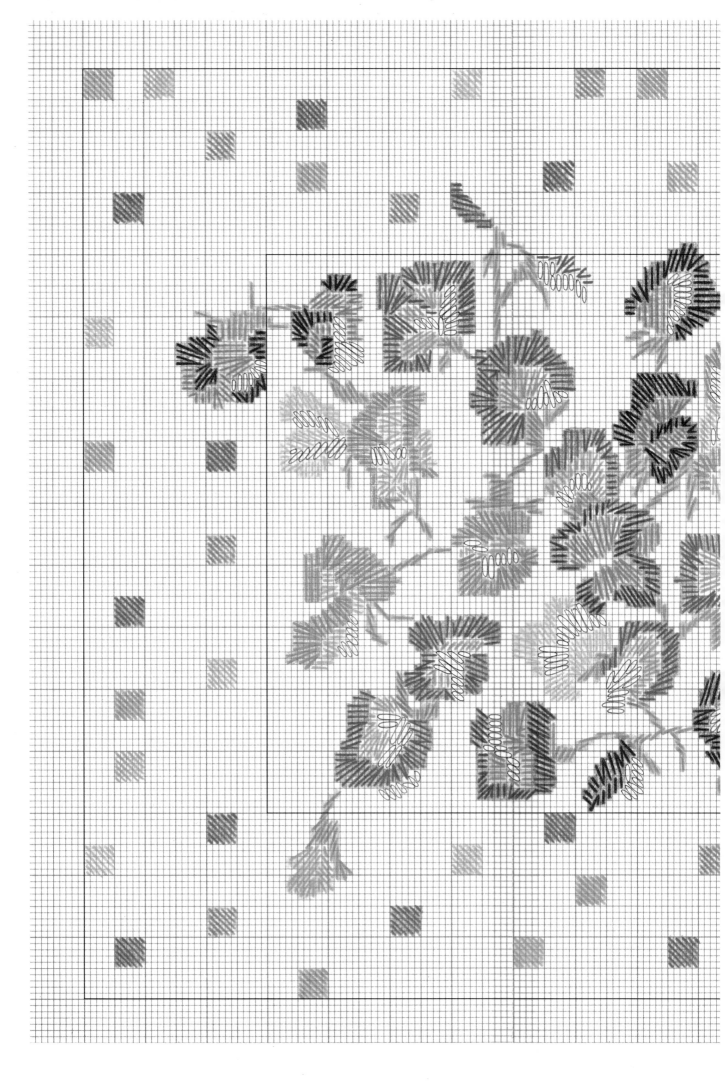

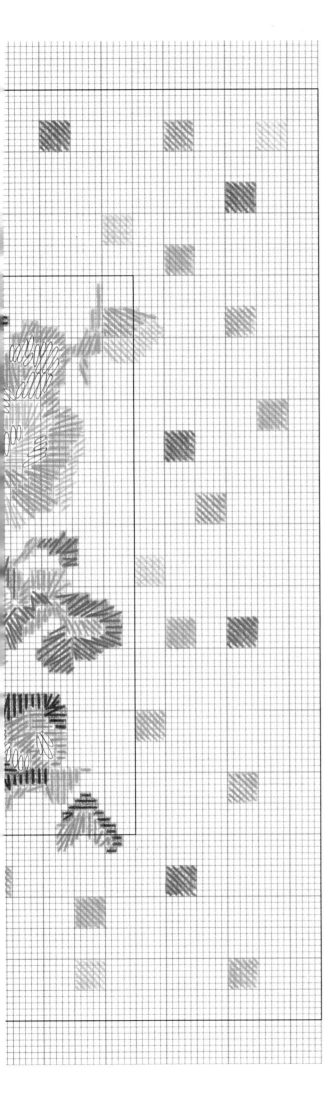

Key

- 16 skeins cream (948)
- 1 skein violet (300)
- 1 skein mauve (302)
- 2 skeins lilac (334)
- 2 skeins light blue (332)
- 1 skein dark rose (931)
- 1 skein pink (945)
- 2 skeins rose (953)
- 1 skein coral (955)
- 2 skeins green (693)
- 1 skein lime green (695)
- 1 skein white (260)

VIOLET EVENING BAG

This simple evening bag has a repeated panel of flowers, which should be worked in satin stitch while the leaves are worked in long and short stitches. Simply follow the direction of the arrows on the chart. The background is worked in tent stitch, apart from the fold lines, which are worked in one row of cross stitch. Each cross should be worked over three stitches horizontally – that is, there are 33 crosses in all. Because the pattern is worked in straight lines, it is important that you use a frame to stop your canvas distorting.

According to the poet Robert Herrick, it was Venus who made the violet, *Viola odorata*, blue. She had been arguing with her son Cupid as to which was more beautiful, herself or a bevy of girls, and Cupid supported the girls. This sent Venus into such a rage that she beat her rivals till they turned blue and dwindled into violets.

A fear of violets exists among English country folk because of the plant's funerary associations. Violets were strewn across graves 'for remembrance' and were said to guard mourners against poisonous exhalations from the cemetery. Despite these morbid associations, the humble violet remains a symbol of romance and is a welcome sight on banks, under hedges and on the borders of meadows where it flowers from March through to May.

In the language of flowers the violet signifies modesty, and from ancient times it has been much loved for its scent and has wide culinary uses.

Of its curative powers Culpeper wrote: 'It is a fine and pleasing plant of Venus, of a mild nature and in no way hurtful. It is used to cool any heat or distemperature of the body, either inwardly or outwardly, as in inflammation of the eyes, in imposthumes and hot swellings, to drink the decoction of the leaves and flowers made with water or wine, or to apply them as poultices to the affected parts.'

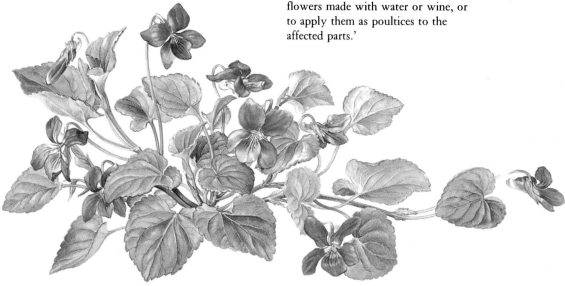

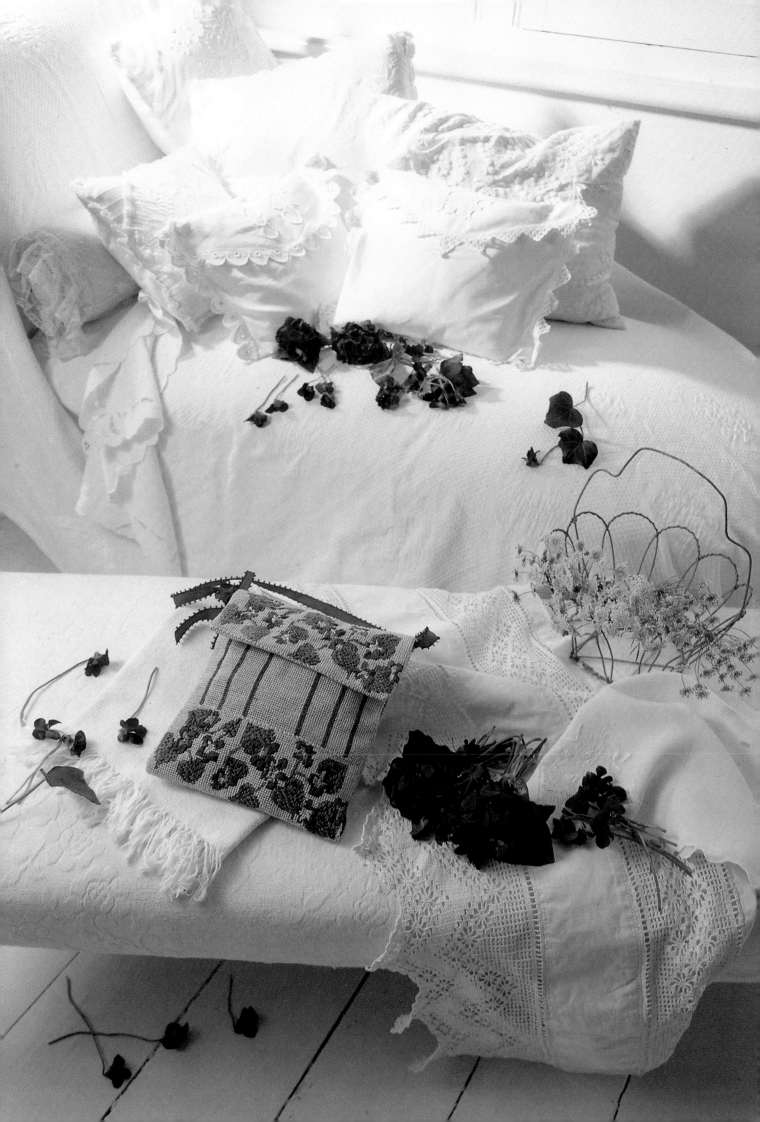

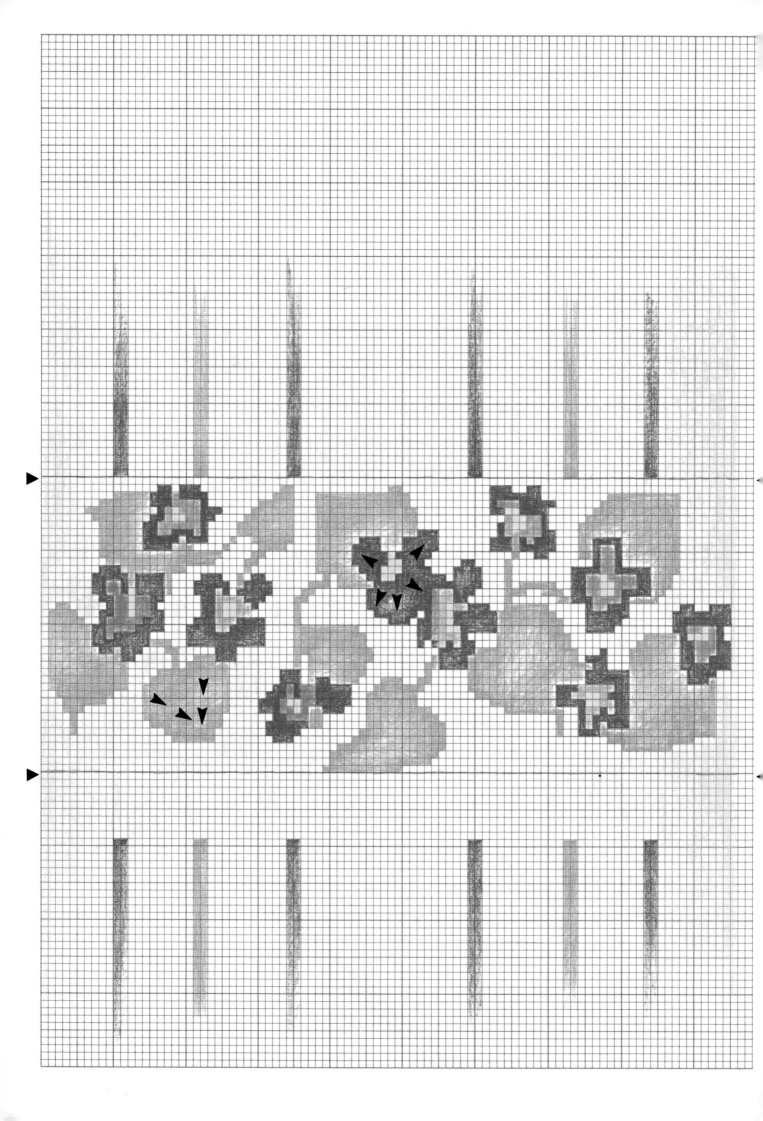

MATERIALS

1 piece of 14-mesh interlocked canvas,
28 × 12in (71 ×31cm); the finished
measurement of the canvas before
folding is 19½ × 7in (50 × 18cm)
10in (25cm) purple lining fabric
Strong purple sewing thread
Blunt- and sharp-ended needles
1yd (1m) purple ribbon for handle
Waterproof pen
Anchor stranded cotton – use six
strands throughout

- 1 skein shaded mauve (01208)
- shaded mauve (01208)
- shaded mauve (01208)
- 3 skeins purple (0100)
- 15 skeins stone (0852)
- 1 skein yellow (0298)
- 3 skeins green (0258)

METHOD

Leaving 2½in (6cm) of waste canvas at
either side of your work, draw a line
99 squares across on your canvas.
Work one row in cross stitch, three
rows wide and one row high, then
work 11 rows in stone in tent stitch,
then one more row in cross stitch as
before. Begin to follow the chart,
working the flowers in satin stitch and

the leaves in short and long stitch in
the directions indicated. Work the
background in tent stitch. When the
panel is complete, work one row in
cross stitch as before. Then work in
stripe sequence for 92 rows. Then
work one more row in cross stitch, six
rows in stone in tent stitch and one
row in cross stitch. Repeat the panel,
then work one row in cross stitch and
60 rows in stripe sequence.

Even though you will have used a
frame, block the canvas carefully (see
Techniques, page 104), taking care to
keep the stripes straight. Cut out an
oblong of lining fabric measuring
8 × 20in (20 × 51cm). Trim away any
waste canvas, leaving ¾in (2cm) all
around the design. Fold back the
excess canvas and press lightly. Neatly
sew the lining to the canvas, starting at
the beginning of the first panel – that
is, leave the first 11 rows of tent stitch
free – and leaving a small opening at
either side through which to thread the
ribbon at the bottom of the first floral
panel. Cut two pieces of fabric, each
measuring 3½in (9cm) at the top and
tapering down, for 7in (17.5cm), to
1¼in (3cm) at the bottom for the side
gussets. Fold the bag and pin the
gussets into position (with the wide
edges of the triangles at the top), then
sew them neatly into place. Thread
ribbon through the opening in the
lining with a safety pin and tie it in a
bow at the side of the bag.

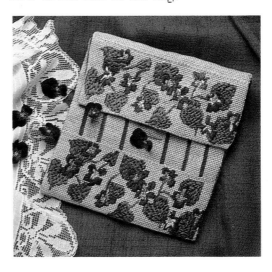

WILD STRAWBERRY WAISTCOAT

This strawberry waistcoat is worked on a tent stitch background. The flowers and the berries are worked in satin stitch, and the leaves are outlined with straight stitches and filled in with tent stitch. The stems are also worked in straight stitch.

The botanic name for the wild strawberry, *Fragaria vesca*, is derived from the Latin *fragans* (fragrant) and *vesca* (edible). In Anglo-Saxon times the plant was known as the streowberie or strayberry because of its long, straying suckers. Another common, although unlikely, explanation for the name is that it arose from the widespread practice of putting straw around the plants to prevent the fruit from spoiling and to keep them safe from slugs.

In the Christian tradition both the flower and the fruit of the strawberry represent the good fruits of the Holy Spirit, while the leaf stands for the Trinity. The berry is also an emblem of the Virgin Mary, who is said to have acquired so great a fondness for the fruit that she demanded all that grew. She guarded her right to the fruit so jealously that, if a mother presented herself at heaven's gate with the stain of strawberries on her lips, she would be cast down by the Virgin in everlasting torment for trespassing on her fields. It was also believed that infants ascended to heaven disguised as strawberries, so people on earth never knew when they were committing cannibalism by eating the fruits.

The wild strawberry can be found wherever there are shady banks and woodland clearings, the white flowers appearing from April to July. Herablists used the roots and leaves to produce a lotion that was traditionally used to heal mouth ulcers and to fix loose teeth. The distilled juice of the fruit was recommended for 'purification of the heart', jaundice and cooling of the liver, spleen and blood.

In the language of flowers, strawberry blossom means 'be on the alert' and signifies innocence. The fruit symbolizes esteem, love and perfection.

Wild strawberries have a flavour and fragrance more delicate than the cultivated variety. They are at their best tossed in a dash of kirsch and served with a sprinkling of caster sugar and lashings of cream.

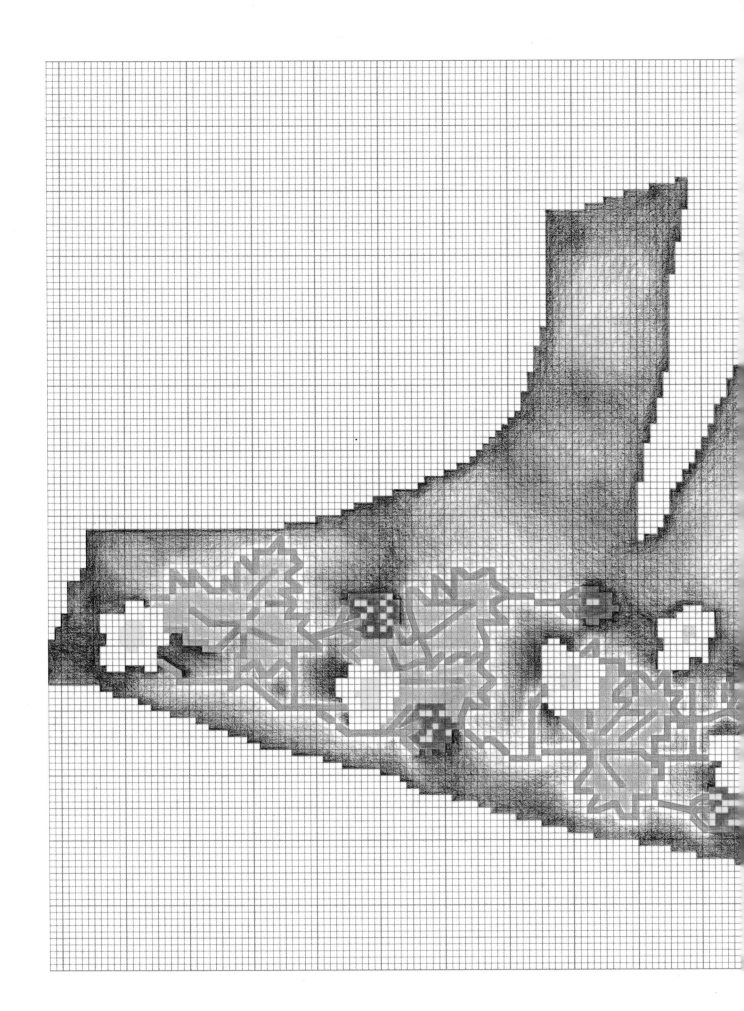

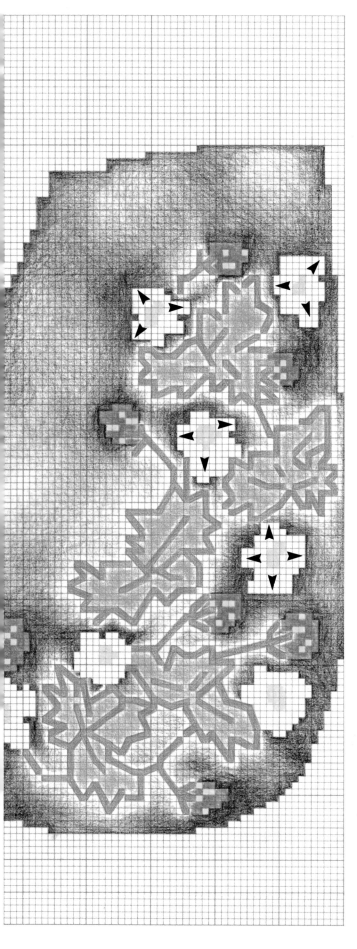

2 pieces of 10-mesh interlocked canvas,
 each measuring 17 × 22in (43 ×56cm)
20in (50cm) black heavyweight fabric
 (wool, cord, cotton or drill)
20in (50cm) black lining fabric
2½yd (2.5m) piping cord and
 covering, ¾in (2cm) wide
Strong black sewing thread
Blunt- and sharp-ended needles
Waterproof pen
Paterna Persian tapestry wool – use
 three strands throughout

21 skeins black (220)
2 skeins dark green (620)
4 skeins green (621)
1 skein yellow (772)
2 skeins red (820)
2 skeins ecru (263)

Note: the pattern is designed to fit bust
size 34–36in (86-92cm).

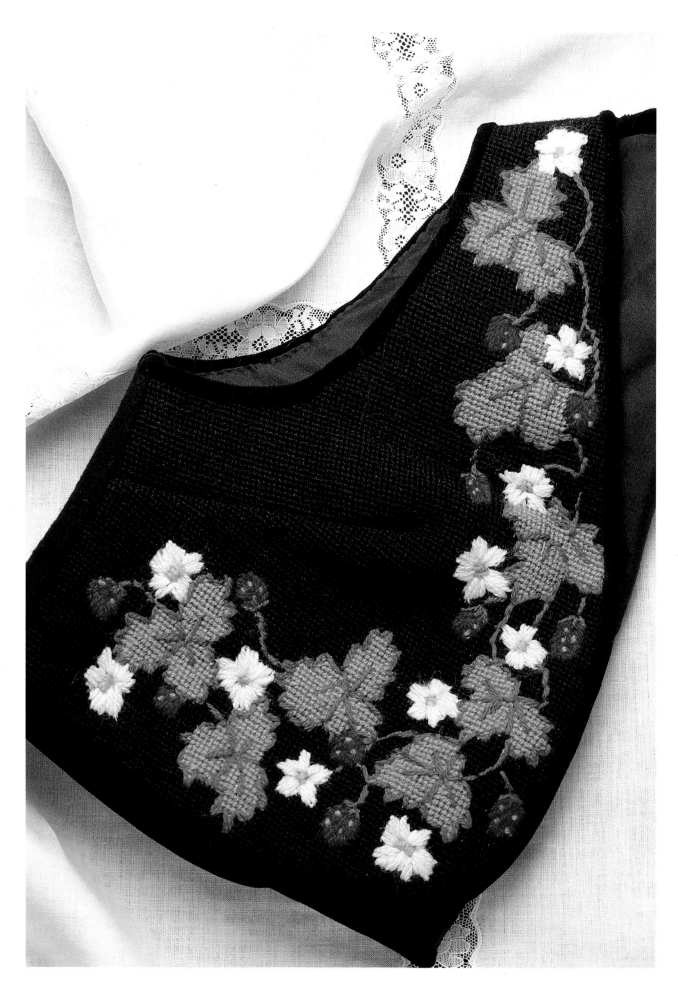

102 · WAISTCOAT

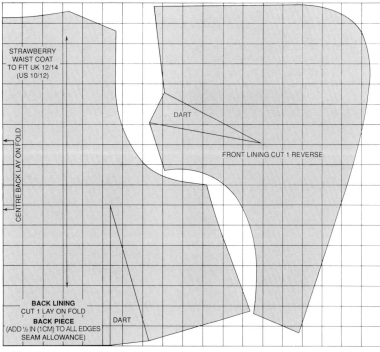

STRAWBERRY
WAIST COAT
TO FIT UK 12/14
(US 10/12)

CENTRE BACK LAY ON FOLD

DART

FRONT LINING CUT 1 REVERSE

BACK LINING
CUT 1 LAY ON FOLD
BACK PIECE
(ADD ½ IN (1CM) TO ALL EDGES
SEAM ALLOWANCE)

DART

1 SQUARE = 1 IN (2.5CM)

METHOD

Leaving approximately 3in (7.5cm) of waste canvas at the top, bottom and sides of the design, take a waterproof pen and sketch a rough outline of the left front directly on to your canvas as a guideline. Complete the background first, working with black yarn in tent stitch and starting at the right-hand corner. Outline the leaves using one straight stitch and fill in with tent stitch. Work the white flowers in satin stitch in the direction of the arrows on the chart, and fill in the yellow centres with tent stitch. Work the flower and berry stems in green straight stitch, then work the red berries in satin stitch, taking care to cover up any of the canvas that is showing through. Add small straight stitches in yellow to the berries. Work a mirror image of the chart for the right front on the second piece of canvas.

When the needlepoint fronts have been completed, cut away any excess canvas, leaving a border of ¾in (1cm) around all edges. Close all darts using black wool and a fine back stitch.

Open the seams on the wrong side and carefully iron them flat.

Cut out the back pattern piece in your chosen fabric, laying the centre back on the fold and remembering to add ¾in (1cm) seam allowance. Close the darts using a fine back stitch. Join the front shoulder edges to the back shoulder edges and then join the side seams with fine back stitch.

Cut out the back pattern piece, laying the centre on a fold in the lining fabric, and cut out the left and right fronts in lining fabric. Do not add ¾in (1cm), seam allowance to the back pattern piece for the lining. Close all darts using a fine back stitch.

Join the shoulder fronts to the shoulder backs and join the side seams with fine back stitch.

Join the lining to the inside of the waistcoat, matching the inside seams of the lining to the inside seams of the waistcoat. As you join the lining, turn in ¾in (1cm) all the way around.

Bind all edges with piping, taking care that the piping does not gather or pucker around the armholes or along the front curves.

TECHNIQUES

As I said in the Introduction, I am not a great stickler
for rules and regulations but rather believe in
improvisation and 'try it and see'. If a way of working
is right for you and gives the results you want to
achieve, that is all that counts. There is, even so, some
information about basic materials and tried and tested
methods of producing stitches that is useful – it can
sometimes mean the difference between a distorted,
lumpy end result and a beautiful square cushion.
Considering the time that you are going to invest in
your work, you might do well to spend a few minutes
reading the following.

TOOLS OF THE TRADE

To make any of the projects in this
book you will require the following
tools and equipment.
- Canvas with the right number of
 holes to the inch (2.5cm) to suit
 your project.
- Stranded wool or cotton in a range
 of colours.
- Sharp-ended sewing needles and
 strong sewing thread in a range of
 colours.
- Blunt-ended sewing needles with
 different sized eyes to fit easily
 through the various meshes of
 canvas.
- A waterproof marking pen.
- A tapestry frame and masking tape.
- Sharp scissors.
- Lining or backing fabric, usually
 cotton.
- Piping cord or ribbon.

CANVAS Needlepoint canvas is produced in various mesh sizes with specific numbers of holes or threads to the inch (2.5cm). In all materials given in this book, where I have referred to mesh sizes this should be taken to mean the number of holes to 1in (2.5cm) and not the number of threads. Mesh sizes can vary from as many 32 holes per 1in (2.5cm) for extremely fine work such as *petit point* to as few as 3 holes per 1in (2.5cm), which is used mainly for rugmaking. I have used a middle range of meshes, ranging from 7 to 18 holes, with most of the projects worked on 10- or 12-hole canvas, which can be covered quickly and yet gives enough detail for the basis of most of my designs.

There are two main types of canvas available: single canvas is composed of a mesh of single, interlocked threads, and double canvas is composed of double, interlocked threads. The latter is good for cross stitch work and for work that requires areas of small detail. I have used single-mesh for all the projects in this book as I find it keeps its shape better and is perfectly adequate for the interpretation of my ideas. However, there is no reason you cannot use double-mesh canvas as an alternative as this is simply personal preference. Canvas is also available in a choice of white or various shades of sepia . . . the choice is yours.

YARNS Any type of yarn can be used for needlepoint – wool, cotton, silk or linen, and even lurex threads if you wish. I have chosen Paterna wools because I consider the quality and range of colours to be superb. Paterna Persian tapestry wools come in hanks that contain approximately 8 yards (7.4m) of yarn, and each hank contains three separate strands of wool, which can be worked together or separately according to the size of your canvas mesh; for example, you should use one strand for very fine work and three

strands for a 10-mesh canvas and so on. Paterna yarns are widely available, but the address is also listed in the stockist's details in case you have any difficulty obtaining them. All the designs in this book are also available as mail order kits, containing the correct amount of canvas and Paterna yarns for each project (see Stockists, page 110).

It is sometimes good to have a more defined effect and in some projects, such as the poppy firescreen and forget-me-not photograph frame, I have recommended Anchor stranded cotton, again because of the quality, colour range and availability. Anchor cotton comes in hanks of 8¾ yards (8m) of six strands per hank, and this also gives you the flexibility of a choice of thickness of yarn to suit various mesh sizes. Anchor also carries a range of special-effect cottons and silks, and these are well worth investigating if you want to make your work look 'different'.

YARN AMOUNTS The yarn amounts listed in this book are only approximate, and do remember to increase the amount of main colour you need if you alter the size of the project.

FRAMES Many books will tell you that you can choose whether to work your needlepoint on a wooden frame or not. Having tried both methods, I can only tell you that the work I have produced using a frame has, in some instances, not even required blocking. One piece of work that was produced without a frame required three people to sit on, stretch and nail the canvas to a wood block before it even began to resemble the shape it was supposed to be. If you are an incredibly even sewer, you can quite happily work a canvas scrunched up on your lap with no worries. If, however, you are prone to bouts of loose or tight stitching, do yourself a

great favour and buy a frame before you begin.

There are various types of frames available. For most projects the straight-sided kind is most suitable. This consists of two pieces of dowling with webbing attached on to which you sew two ends of your canvas. These pieces of dowling slot into two upright members, which hold them rigid. You then roll the canvas on to the dowling until the fabric is absolutely taut and secure the whole thing with the four wing nuts that are supplied with the frame. Frames come in a variety of widths, and you should chose according to the width of your work. They are very reasonably priced and well worth the money.

The second type of frame most often seen is round and consists of two circles of wood, one of which has a screw across the top. You place one circle underneath your work and clamp the second over your work, tightening the screw until the fabric is taut. These frames come in a wide range of sizes, and they are especially useful when working small needlepoints on small meshes of canvas or on a fabric such as evenweave linen.

There are various stands available to support your frame, some are made of beautiful, polished wood to enhance your living room; some are made of stainless steel, with the emphasis on adjustability to enhance your comfort. There is a wonderful stand called an Emu, which is based on the same principle as an anglepoise lamp. Once your frame is attached, it can be bent and twisted into so many positions that you can produce your needlepoint lying flat on your back if you wish. It is a little ugly to live with and can make some very strange noises as you turn and twist it, but I simply regard mine as a rather eccentric pet who lives quite happily behind the sofa and enables me to sew stretched out on the couch whenever I want (see Stockists, page 110).

MASKING TAPE If you do not intend to use a frame, it is advisable to bind the raw edges of your canvas with masking tape. This prevents the canvas snagging on your wool and also protects your hands from the sharp edges. Even if you use a frame, you might still find it helpful to bind the edges of your canvas.

STOOLS Several styles of stool and needlework box frames are produced specifically to take tapestries, but there are very few to my personal taste. For this reason, I commissioned Roger Newman, my local rocking-horse maker, to design a hand-carved stool and chair that I could use for my needlepoints and offer my readers. I used these for the marshmallow chair seat and the honeysuckle footstool (see pages 52 and 38). Both these items are available by mail order and can be supplied assembled in polished wood or in kit form, ready to be rubbed down and polished (see Stockists, page 110).

The one golden rule in needlepoint is that when you are working in half-cross stitch or tent stitch all your stitches should slant the same way.

HALF-CROSS STITCH Work from left to right, bringing the needle up through the canvas and making a small diagonal stitch, going in one hole up and to the right. Bring the needle to the front

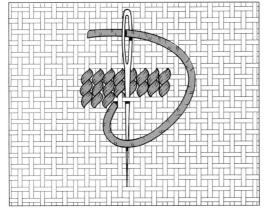

again one hole vertically downwards. Continue to the end of the row, then turn your work upside down to work the next row.

TENT STITCH This is undoubtedly the most popular needlepoint stitch, and it is often used in preference to half-cross stitch because it gives such a durable finish. The diagram below shows how the stitch is worked and the end result, which is a flat, slanted stitch over one row.

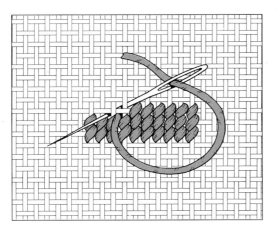

STRAIGHT STITCH When I refer to straight stitch I am usually using it to edge leaves or to form stems. As its name suggests, this is a straight stitch that is used to cover a defined area, and it is worked in the same way as back stitch in sewing. Do not use two stitches where one will do, but do not make the strands on the front of your work too long, as fingers and other paraphernalia might catch on them.

SATIN STITCH Satin stitch is used to cover areas quickly and to obtain a three-dimensional effect. Because there are no rules about the number of times you can go into the same hole of canvas when you are working with this stitch, it is also useful for creating subtle curves at the edges of petals, which is something you cannot do with tent stitch. Simply oversew the area in question, working in the direction of arrows where these are indicated on the charts and graduating the size of the stitches gently as you go to get the correct shape. You may find it helpful to have an extra strand of yarn in your needle when working this stitch to ensure that the background is completely covered.

GRADUATED DIAGONAL STITCH I have used this as a border stitch on both the sweet pea cushion and the garlic and chive book cover (see pages 88 and 32). It is simply produced by taking an

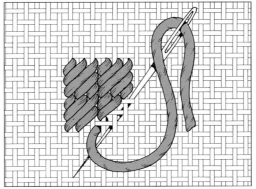

area of, say, four holes by four holes on your mesh and, starting with the top corner, working the square diagonally, increasing the size of your stitch as you go and then reducing it down to the bottom corner. The diagram on page 107 shows how the squares of stitches should fit together.

SCOTTISH STITCH This is worked on the same principal as graduated diagonal stitch except that each square has a border of one row of tent stitch.

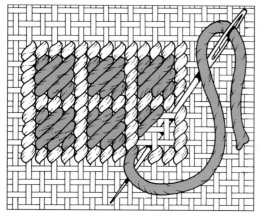

The easiest way to work is to produce the grid of tent stitches and then to fill in the spaces in between with diagonal stitch worked over one, two and three threads of the canvas as shown in the diagram above.

CROSS STITCH I have used two forms of cross stitch in this book. On the violet evening bag (see page 94) I have worked crosses over one strand of canvas vertically but over three holes horizontally. On the rose rug (see page 74) I have worked the crosses over squares of canvas three holes across and

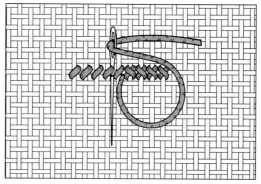

three holes high. The diagram above shows the direction in which the stitches should be worked. Remember that the upper stitches should all slant in the same direction.

FRENCH KNOTS These are used for flower centres and are made by bringing your needle up through the canvas and wrapping the wool or cotton around the needle three times.

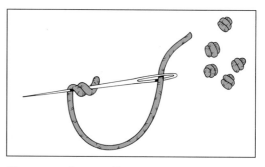

You can then pull your needle through the wrapped yarn and down through a hole adjacent to your starting place, thus forming a small knot (see the diagram above).

LONG AND SHORT STITCHES I have used long and short stitches to emphasize the direction on a leaf and to give a shaded effect. They are simply straight stitches of different lengths worked next to each other – that is, the first stitch could be worked over four holes and the second stitch over three holes, giving a random effect.

READING THE CHARTS

The charts in this book are not drawn in proportion to the size of your canvas; each square on the chart represents a hole in your canvas, and colour areas should be worked as closely as possible to the area indicated.

JOINING PIECES OF CANVAS

There is no reason why small pieces of canvas cannot be joined – you may, for example, wish to reproduce the rose rug chart several times to produce a big rug! To do this, simply overlap the pieces of canvas by at least six holes and stitch your design over both thicknesses. Alternatively, squares of the design can be worked separately and stitched together with strong upholstery thread when the work is complete. When using this second method, line your finished item to protect it against heavy wear.

To make your rug non-slip, paint rubber-based adhesive over the back and leave to dry thoroughly. You could, if you prefer, stick a piece of rubber underlay on the back.

AFTERCARE

No matter how many times you wash your hands, your work will inevitably get grubby. Provided you have used a waterproof marking pen there is no reason why you cannot wash your work in very cool water using one of the washing agents especially produced for delicate fabrics. Do not squeeze but leave to soak for a few minutes before rinsing thoroughly. Remove any excess water by rolling your needlepoint up in a towel. Allow it to dry away from strong sunlight.

BLOCKING

If you do not use a needlepoint frame you will have to block your work when it is complete. To do this, you need a wooden frame (an old picture frame would do) or a largish piece of wood and some upholstery or drawing pins. Simply stretch your canvas into shape and pin it down firmly, using at least one pin every 1in (2.5cm) all around the work. Using a water spray of the kind sold for misting indoor plants or a damp sponge, moisten your work throughly on the wrong side and leave it undisturbed until it is completely dry, which may take up to a week or more.

STOCKISTS AND SUPPLIERS

Kits for all the projects in this book are available by mail order. The kits contain the correct size canvas, appropriate yarns and a sewing needle. A selection of the designs are also available with printed canvases. For full details and prices write to

Melinda Coss
T'yr Waun Bach
Gwernogle
Dyfed
West Wales
SA32 7RY
Tel: 0267 202 386

Needlepoint frames, stools, workboxes, chairs and blank greetings cards are also available by mail order from the above address.

Emu needlepoint stands are available from

Portfo'lio
30 The Boardwalk
Port Solent
Portsmouth
Hants PO6 4TP

If you have difficulty in obtaining Paterna Persian tapestry wool, contact

The Craft Collection Ltd
Paterna from Stonehouse
PO Box 1
Ossett
West Yorkshire WF5 9SA
Tel: 0924 276 744

Queries about Anchor stranded sewing cottons should be addressed to

Anchor Stranded Cottons
Coats Patons Crafts
P.O. Box, McMullen Road
Darlington
Co. Durham DL1 1YQ
Tel: 0325 381010

Canvases may be obtained from

The Readicut Wool Company Ltd
Terry Mills
Ossett
West Yorkshire
WF5 9SA
Tel: 0924 275 241

The cushions, cushion pads, fabrics, cottons and cord trims used for these projects were all purchased from John Lewis, Oxford Street, London W1. All of these items are readily available in major department stores worldwide.

The mechanism for the dandelion clock (see pages 16–21) may be obtained from

Shoot & Sons
Renata House
116–118 St John Street
Clerkenwell
London EC1
Tel: 071 253 9462

US STOCKISTS AND SUPPLIERS

The materials necessary for these designs can be found in any good department store. If you have difficulty in obtaining Paterna Persian tapestry wool, contact

Johnson Creative Arts
455 Main Street
West Townsend
MA 01474
USA
Tel: (617) 597 8794

Details of suppliers of Anchor handicraft threads are available from

Coats & Clark
PO Box 24998
30 Patewood Drive
Suite 351
Greenville SC 29615
USA
Tel: (803) 234 0331
Fax: (803) 675 5609

Kits for the projects in the book are available from Melinda Coss from the address given above.

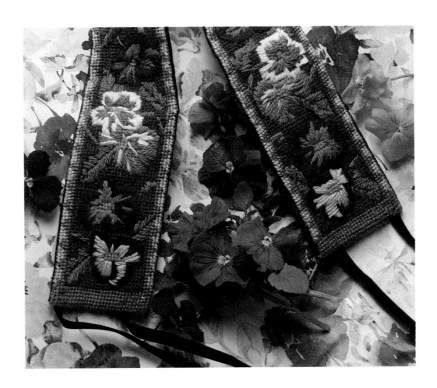

BIBLIOGRAPHY

I consulted the following books in the course of researching information on flowers, their folklore, recipes and remedies.

Addison, Josephine, *The Illustrated Plant Lore*, Sidgwick & Jackson Ltd, 1985

Bremness, Lesley, *The World of Herbs*, Ebury Press, 1989

Mabey, Richard, *The Complete New Herbal*, Elm Tree Books, 1988

Phillips, Roger, *Wild Food*, Peerage Books, 1988

Pickles, Sheila, *The Language of Flowers*, Pavilion Books Ltd, 1990

Skargan, Yvonne, *A Garland of Wild Flowers*, A. & C. Black, 1980

Skinner, Charles M., *Myths and Legends of Flowers, Trees, Fruits and Plants*, C. J. Lippincott, Philadelphia and London, 1913

Smith, William, *Wonders in Weeds*, C. W. Daniel Co. Ltd, 1977

ACKNOWLEDGEMENTS

I would like to take this opportunity to thank Helen Barras at Paterna Yarns and Sarah Harper at Anchor (Coats Leisure Crafts Group) for their help and support while this book was in preparation; Lydia Darbyshire, Pauline Young, Heather Shilvock and Eleanor Symeou for their excellent stitching; Roger Newman for his wonderful carved pine stool and chair; Di Lewis for her stunning photography; Suzanne Dosell for minding the shop; and Ray Cooper for keeping me company during the endless nights of stitching.

INDEX